Athens

Scenes from a Capital City

For the new generation:

Benjamin, Richard, Nicholas and Philippa
Andreas and Anna

◆

ILLUSTRATOR'S ACKNOWLEDGEMENTS

Athens is a city I have visited annually for over 30 years but for which, until I embarked on photography for this book, I had only superficial appreciation. One of the joys of working on the book has been the discovery of so much that previously I had seen but not noticed. I hope readers too will find here something new among the familiar in a city that is at once so old and yet so young.

I owe a great debt of thanks to many Athenians, good friends and friendly strangers, and to many Greeks overseas, who helped in so many ways in my exploration of their wonderful capital and responded to my thirst to know more of its architectural and human history.

But above all my heartfelt thanks are due to two people without whom, it is literarily true, this book would not have appeared.

Betty Godley, a dear friend and fellow trustee of the American Farm School in Thessaloniki, stepped in, unasked and immediately, with such generous support that there was no question that I could proceed with Athens as my second book for my publishers.

And for the second time, the encouragement, help and forbearance of my wife Laura, whose birthplace is celebrated here and who set me on the path of computer-generated sketches in the first place, has been crucial and has meant everything to me. Thanks again, Lauramou.

John Cleave

John Cleave's royalties on this book are being donated, in their entirety, to the Annual Scholarship Fund of
The Thessalonica Agricultural and Industrial Institute, also known as the American Farm School.
Readers wishing to learn more about the 100-year-old institution,
contribute to its work, or seek information on student enrolment are invited to look at
www.afs.edu.gr/support

The publishers gratefully acknowledge the generous support of the sponsors.

ELIZABETH McCRAY GODLEY

HERACLES
GROUP OF COMPANIES
A Member of LAFARGE

HOTEL
GRANDE BRETAGNE
Athens

Illustrations

Endpapers: Graceful double doorway at 46 Sina Street. p. 1: Skiron, the north-west wind, scatters glowing ashes symbolising warmth.
p. 2: Plaka, the old town of Athens. p. 5: Michalis Tombros's 1966 bronze of Georgios Karaiskakis, a revolutionary hero, stands in the National Gardens.

Illustrations, captions and gazetteer © JOHN CLEAVE • Original Greek introductory texts © NIKOS VATOPOULOS
English translation of introductory texts © VIVIENNE NILAN
Design and typography © EDITIONS DIDIER MILLET 2005
First published in 2005 by EDITIONS DIDIER MILLET • 121 Telok Ayer Street, #03-01. Singapore 068590.
Reprinted 2006

www.edmbooks.com

ISBN 981-4155-32-2

editorial director: TIMOTHY AUGER editor: CHRISTOPHER KHOO designer: TAN SEOK LUI production manager: SIN KAM CHEONG
Colour separation by Pica Digital Pte Ltd, Singapore • Printed in Singapore by Star Standard

Athens
Scenes from a Capital City

by
JOHN CLEAVE

Introductions by NIKOS VATOPOULOS • *English translation by* VIVIENNE NILAN

Editions Didier Millet

Contents

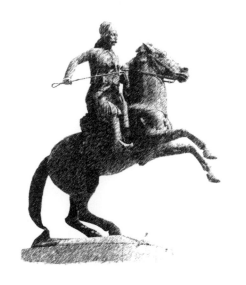

The badge of Athens features the head of the goddess Athena, blessed with wisdom, protector of the arts and keeper of the peace. The municipality was created in 1835.

Scenes from a Capital City

Athens is a city that bears the stamp of the twentieth century. Moving into the twenty-first century, it becomes apparent that the city is striving to shrug off part of its past and replace it with something new, something that has not yet acquired a name, style or identity.

You feel it in the air as you walk along the main streets of Athens. It is not just the shops and renovated buildings—it is the people, the crowds moving ceaselessly like a wave down the pavements. It is written on their faces, their clothes, and is audible in their laughter, which is frequent, and their bickering, which is just as frequent. In the screeching brakes and din of the countless motorcycles that swarm the streets of Athens, you can feel the pulse of today. Both antiquity and the future come within this city's compass.

But it is rarely through its contemporary hubbub that visitors make their first acquaintance with the Greek capital. Inevitably the first encounter is through the city's history. Indeed, no matter where you dig in Athens you come across relics of its past—archaic, classical, Hellenistic or Roman. Everywhere marble fragments, columns, tombs and utensils are unearthed during work on the foundations of new buildings; and archaeologists examine every single find. Excavation works for the metro underground railway, the pride of Athenians since 2000, revealed an entire city beneath the city including networks of pipes and drains, cisterns, art works and even a dog cemetery. Layers of life—now inert, decomposed and silent—lie just a few metres below the pulsating contemporary city. Walking in Athens, you know that beneath your feet are countless remains of past glory that perhaps generations to come will uncover as the city ages and demands renewal.

But there's a simplicity to Athens. You will not find many grand boulevards here, multi-storey mansions with domes and little towers, or gleaming skyscrapers that indicate economic recovery. Despite massive expansion, despite the construction that went on after World War II, life in Athens retains a very human scale. No matter how built-up the city becomes, the buildings are usually around five storeys high, eight at the most; and scattered among them, like old photographs in a digital era, are the remains of its neoclassical past.

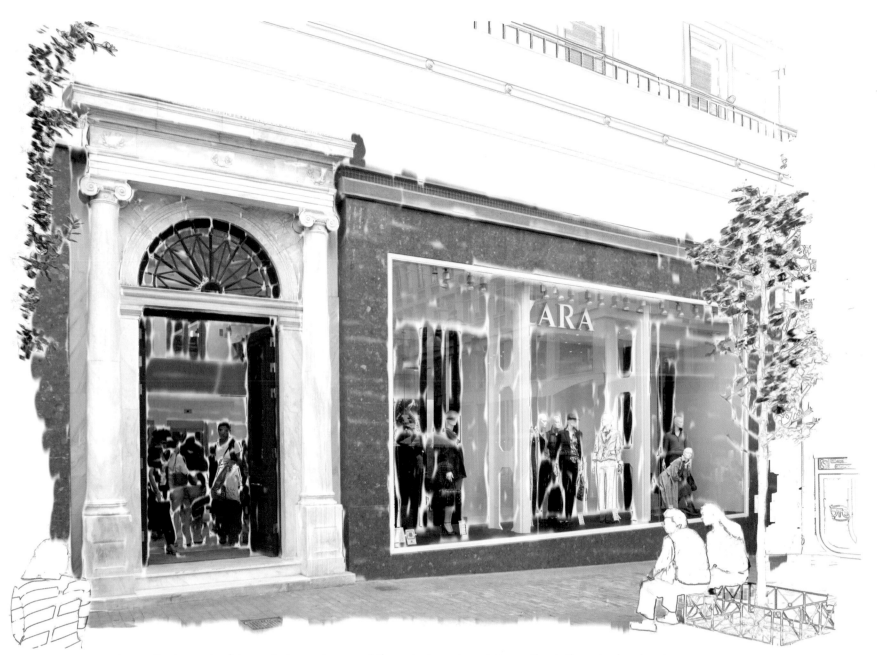

Ermou Street, running between Syntagma Square and the ancient cemetery at Kerameikos, is the main shopping street of Athens. The section that is closest to Syntagma Square has been pedestrianised and the fashionable stores that line either side occupy neoclassical buildings whose integrity has been preserved.

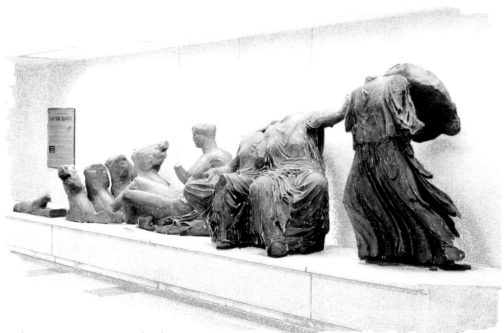

*Athens's metro stations, works of art
in their own right, are used effectively to display artifacts found during their
construction, showcasing the city's history. In Acropolis Station, copies of
sculptures from the Parthenon's east pediment, made by Pheidias from
438–432 BC, are also displayed. The originals are in the British Museum.*

However, Athens does boast some some of the grandest nineteenth-century public buildings to be found in Europe. In the city centre on Panepistimiou Street stand the National Library, built in 1903; the University, built in 1864; and the Athens Academy, built in 1885—imposing neoclassical edifices designed by the Danish brothers Christian and Theophil Hansen and constructed with funds provided by national benefactors. The Greeks refer to these buildings, which stand in a row, as Hansen's Trilogy.

Recently, Dionysiou Aeropagitou, the famous street at the foot of the Acropolis, became a pedestrian walkway, where one may encounter the most fabulous buildings. On one side of the street lies the living landscape of classical antiquity, the Acropolis crowned by the Parthenon. Steep slopes lend drama to the scene, which is softened by olive and cypress trees and flowering shrubs.

On the other side of the road are some of the finest examples of nineteenth- and early twentieth-century houses, built in the Athenian neoclassical style inextricably associated with modern Athens until the 1960s.

When I was growing up in Athens in the 1960s and 1970s, the city was being rebuilt from scratch, though I did not realize exactly what was happening at the time. After the war, the city suddenly expanded to gigantic dimensions, attracting mass migration from the countryside. Athens fulfilled dreams of housing and jobs. Now it satisfies the desire for anonymity of thousands of young people from the provinces who seek cosmopolitan freedom in the capital.

If you want to understand the contemporary architecture of Athens, with its signature blocks of flats, you need to keep the modern city's short history in mind. If anything is typical of this city it is these five- or six-storey apartment blocks—flat-roofed rectangular buildings with potted plants, and awnings that shield them from the intense sunlight. This type of block can be seen everywhere in Athens, in variations ranging from the crudest to the finest quality.

Seen from above, the dense fabric of apartment blocks gives the impression of an unbroken sea of cement, but seen up close and at street level, Athenian blocks of flats—however nondescript they might be in architectural terms—are more human. There is no comparison with the overwhelming architecture of the tower blocks still to

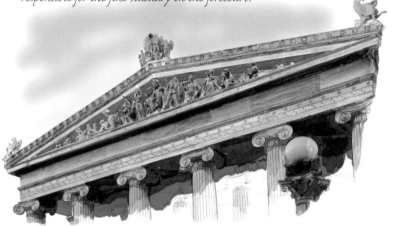

be seen on the outskirts of London. In Athens, the scale is usually smaller, and even densely-populated quarters are redeemed by a sense of neighbourhood. The Athenian block of flats is a Mediterranean architectural hybrid. It is reminiscent of similar buildings in Italy or Lebanon, but although development in Athens followed a purely commercial course and the architecture was usually anonymous, the starting point was much more ambitious.

When the first multi-storey blocks went up in the 1930s, most were privately built and designed by elite architects who drew their inspiration from Bauhaus and Art Deco. Most of these early buildings, now 70 years old, have survived, and the observant onlooker can discern in them some of the most exciting examples of 1930s architecture in southern Europe. Besides, aesthetic polyphony is one of contemporary Athens's strong points. Many streets in the Greek capital have buildings with facades from different periods and in different architectural styles. In a single street block you can see buildings from the 1970s, 1950s, 1930s, 1910s and 1880s side by side. All together they make up that very special Athenian urban atmosphere.

Athens is a vast city, but within the confines of its historic centre, and in spite of the crowds, the traffic and the co-existence of Greeks and foreigners that bestow upon it the air of a metropolis, it is difficult to get a sense of its true size. Athens is expanding in every direction and the eventual, total urbanisation of Attica is merely a matter of time.

Few visitors are aware that just 15 to 20 kilometres from the centre of Athens towards the cosmopolitan southern suburbs, you can find organised beaches that are packed with people from May to September. Places that just a few decades ago had nothing but seaside villas and wasteland now boast luxury hotels, clubs and busy shopping centres, forming a densely built-up shoreline that fancies itself as the Athenian Riviera.

One of the finest routes in Athens is the coastal road, most of which is now served by the brand-new tramway. From Piraeus to Sounion and the ancient temple of Poseidon, the seafront of Athens offers a carefree holiday atmosphere summer and winter with expensive flats, designer boutiques and never-ending development. It is the epitome of the Mediterranean lifestyle.

At the other edge of the city, in the northern suburbs, the atmosphere changes. There is the same dynamism, the same appetite for consumerism and entertainment, but the climate, architecture and relationship with the city itself are all different.

Kifissia, to the north of Athens, has been a cool, leafy suburb ever since Roman times and is often thought of as the polar opposite to seaside Glyfada. One of the most prosperous and rapidly developing areas in Greece, Kifissia is also famed for its nineteenth-century villas—those that survive among the maisonettes and shopping malls. The villas of Kifissia, copied from Italian and German architectural models, were the bastions of the Athenian upper middle class. Looking at these grand romantic villas in their large gardens with their ancient trees, it is hard to believe that notorious, rowdy Omonia Square, situated in the centre of Athens, is part of the same city.

Although recent changes in Athens have been erasing all remaining traces of the past in the city neighbourhoods and outlying suburbs, the centre certainly seems to be racing against time to recapture its former lustre. For those who can remember what the atmosphere downtown was like 20 or even 10 years ago, this transformation has been spectacular. Since 2000, the historic and commercial centre of

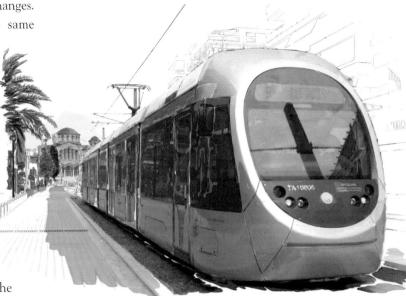

The Tram returned to Athens in July 2004 with two lines from Syntagma Square down to the coast, and a third linking the two coastal terminals of Glyfada and Neo Faliro. The view shows a tram at Mousson.

Athens has been attracting investments and many young people, mainly Athenians, who are looking for a flat or, better still, an old house with character, have responded to its appeal.

I enjoy walking round central Athens at night; more and more buildings are being illuminated, which gives the city a completely different feel.

For many foreigners, Athens is the Acropolis, but for local residents, Athens is where life is. And life buzzes throughout the large area bounded by the three main squares—Syntagma, Omonia and Kolonaki. This is where it's all happening; this is the heart of contemporary Athens.

Syntagma—or Constitution—Square, which took its name from the people's demand for a constitution in 1844, is the most cosmopolitan and friendly square in Athens. It is home to the city's largest metro station, and as I walk across it I often wonder what this historic square would be like if the nineteenth-century neoclassical mansions that bounded it on all sides as late as the 1950s and 1960s had survived. Few of them escaped the mania of those decades for reconstruction. Despite the loss of significant buildings, Syntagma is

still the best place to get acquainted with contemporary Athens. Large hotels such as the historic Grande Bretagne and the King George II are within walking distance of the pedestrian zone of Ermou, the most famous shopping street in Athens.

The city's prime example of neoclassical architecture is Vasilissis Sofias Avenue, which took its name from the German princess who married Constantine, the heir to the Greek throne. A sister of the Kaiser, she opposed Greece's entering World War I on the side of the Entente. Fortunately, however, her wishes went unheeded, but curiously enough, her name was immortalised when one of the city's most elegant thoroughfares was renamed after her.

Vasilissis Sofias Avenue—which starts at the Parliament, an austere Bavarian neoclassical structure built in 1842—is an Athenian showpiece. To the right, the National—formerly the Royal—Gardens, are an example of Romanticism applied to the art of gardening. To the left is Kolonaki, some of the most expensive real estate in Athens, crowded with cafes and designer boutiques that are usually housed in six-storey blocks of flats. These buildings either have Art Deco lobbies or the 1950s look that is coming back into fashion.

However, the best way to appreciate Vasilissis Sofias is to approach it from the Megaron Mousikis, the Athens Concert Hall opened in 1991, and not from the Parliament. I think every visitor to Athens should take a walk from the Megaron Mousikis towards Syntagma. The best time is on one of those days when there is a light northerly breeze, sunshine and a temperature of 15 to 20 degrees Celsius.

On days like these, Athens gleams as if freshly washed in the sunlight, a sunlight so bright that you cannot venture outdoors without sunglasses, even in January, the coldest time of the year. Light shines

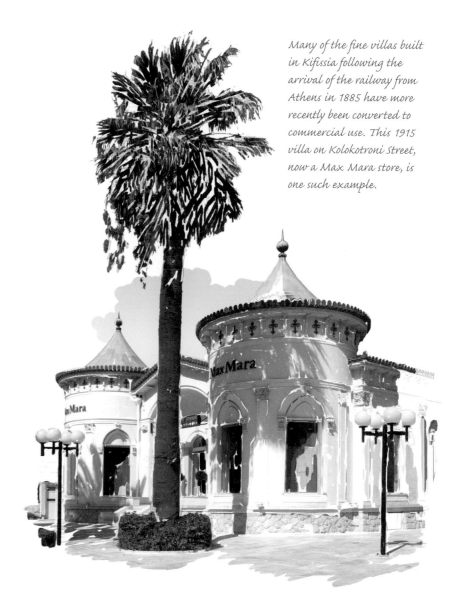

Many of the fine villas built in Kifissia following the arrival of the railway from Athens in 1885 have more recently been converted to commercial use. This 1915 villa on Kolokotroni Street, now a Max Mara store, is one such example.

Many of Athens's residential streets are embellished with graceful light standards.

everywhere, bouncing off pale buildings and the metal panels of cars.

I would like to see more tiled roofs and trees in Athens, but walking the length of Vasilissis Sofias as it is now is a genuine Athenian experience. A hundred years ago, this broad street was vaunted as the only real boulevard in Athens, especially the stretch of it between the site where the Hilton now stands and the Parliament.

One side of the road, towards swanky Kolonaki and the hill Lycabettus, used to be flanked by two-storey villas set in gardens, their borders marked by ornate railings entwined with jasmine. These villas, often in neoclassical or eclectic styles, were the showcase of the most Europeanised middle class in Athens. Most of them fell victim to the building boom that followed World War II. The embassies of Egypt, France and Italy, and one wing of the Cycladic Museum are housed in such villas of the Athenian Belle Epoque.

The aristocratic, Mediterranean air of Vasilissis Sofias makes it unique but what makes Plaka unforgettable is something profoundly Greek. Plaka nestles in the shadow of the Acropolis and is the oldest neighbourhood in Athens. There are none of those rows of apartment blocks whose unrelenting presence can provoke visual boredom. Everything in Plaka is on a small scale. It is the old town within the city, where you get the feeling of walking through a charming vil-

The French Embassy on Vasilissis Sofias Avenue is housed in the stately neoclassical Hotel Merlin de Douai, designed by Anastasios Metaxas in 1894.

lage on an island or a small nineteenth-century town of dolls' houses.

Among the attractive two-storey houses from the 1880s and 1900s are antiquities such as the famous Monument of Lysicrates, Hadrian's Library, Byzantine churches dating from the tenth and eleventh centuries, as well as remnants of the city's Ottoman past, of which Athens has few notable architectural traces. Greeks have only recently, and reluctantly, begun to feel comfortable about including Ottoman ruins in the historical heritage of Athens. The Ottoman rule of Greece, which lasted for four centuries till the 1820s, was a traumatic experience for the Greeks.

There is the Mosque, known locally as the Tzami, in Monastiraki Square, with its minaret destroyed (a fate shared by many mosques in Greek territory in the nineteenth century) and the city's most impressive Ottoman remains, the Baths. These are in a small building in Plaka that has been superbly restored, and are well worth a visit for anyone interested in understanding the city's history.

Greeks tend to shun references to the city's Oriental past, but that is what dominates the market on Athinas Street and the area surrounding Omonia Square. Although fading, the atmosphere of the Near East, which has its own charm, can still be found there in the innumerable shops selling food,

tools and household goods. Springing up amid these traces of centuries past are the ambitions of the new Athens, which is forever striving to assert a new identity. Alongside old stores reminiscent of Istanbul or Beirut are new hotels that revive the pop art aesthetic of the 1960s or attempt to reproduce Old World elegance. Here, new department stores lure shoppers to places that just a few years ago were exclusively associated with the working class, Greeks from the provinces and migrants from the Balkans, Africa and Asia.

Athens is still struggling with itself. This is the impression it gives as the older generations, who are more attached to the Orthodox Church and traditional family values, move out from the old neighbourhoods, making way for a mixed population that will set its mark on Athens for the first time in the city's history. Few old neighbourhoods are without their permanent foreign residents—Albanians, Russians, Egyptians, Ukrainians, Georgians or Poles. Athens now has its own Chinatown near Omonia. Sudanese, Nigerians, Pakistanis and Kurds have also formed their own close-knit communities.

Together with this multinational population that is putting down its roots in the Greek capital, the young Greeks—taller, better looking, richer, more widely travelled, more "European" than their grandparents—seem to enjoy the pace of the metropolis. Athens is a happy city and its crowded cafes give it a carefree atmosphere. In the past few years, cafe culture has taken off and Italian coffee in all its variety has prevailed over Greek coffee. Ever since World War II, Athenians have been rapidly embracing a middle class way of life, a relentless process that is still going on.

Landing at Eleftherios Venizelos Airport, which opened in 2001, you can see the low mountains of Attica, the Aegean Sea, fields sprin-

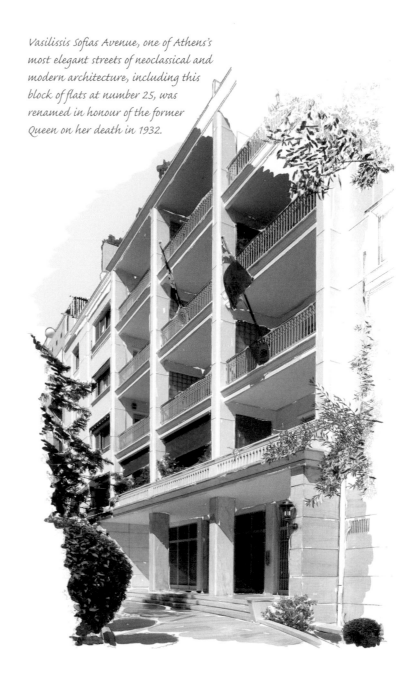

Vasilissis Sofias Avenue, one of Athens's most elegant streets of neoclassical and modern architecture, including this block of flats at number 25, was renamed in honour of the former Queen on her death in 1932.

On Kolonaki Square, coffee shops are the focus of social life. This upmarket district got its name from a small column found, and which still stands, in the square. The square is also titled (but never called) Filikis Etaireias (Society of Friends) Square, after an organisation created in Odessa to support the Greek struggle for independence.

kled with spring flowers, and the newly-built temples of consumption, the vast shopping centres near the airport that serve thousands of customers daily. The triumph of consumerism in Athens not only drives the economy but also defines the way of life. Many say that life has become much more prosaic, limited, difficult and boring now that Athens is prosperous. If you watch the privately-owned television stations, you will see the rampant Philistinism that regularly comes under attack for stifling interest in intellectual life. Yet it would be unfair to judge Greece by its television, which is pretty much the same as television everywhere.

Athens has over a hundred theatres and a burgeoning visual arts scene. New galleries are turning their backs on upmarket Kolonaki and are opening in the old working-class neighbourhoods of Gazi and Psyrri that have recently become magnets for investment in nightclubs, restaurants and theatres.

There is a strong sense that a large percentage of young people want to move ahead. You can see it in their dress and body language, and in the lifestyle that for some years now has abandoned the traditional siesta and family dinners. Athens, with all its pluses and minuses, is constantly building up the image it wants to project of being a modern Western metropolis in the Eastern Mediterranean. Suddenly the 1960s and 1970s, when Athens still looked exotic to tourists, seem very distant. Then, Athenians were unaware that their lifestyles and the city itself would change.

If you talk to young Athenians you'll see there is an intense need for expression of this new Greece and its metropolitan lifestyle. Many older people are annoyed by the retreat of the tradition that was defined for decades by an inward-looking devotion to the Greek Orthodox religion and family culture.

Nevertheless, both the Church and the family still exert a powerful influence on the rhythms of everyday life in Athens, though not as pervasively as they once did. Both Church and family have now acquired a worldliness that has completely assimilated them into a contemporary Greek way of thinking.

From morning to night, Athens goes through several striking transformations that reflect its pluralism and the different lifestyles that coexist, as in any large city. Driving along Kifissias Avenue by night towards the northern suburb of Kifissia, you will see glass towers topped by the logos of vast multinational companies.

On Iera Odos—the Holy Way of antiquity—parked cars block the road till dawn outside nightclubs reigned over by the stars of popular Greek commercial music (an amalgam of Latin and oriental pop). In Piraeus, the city's ancient port, you can still find wine and meze shops redolent with the atmosphere associated with the first migrants that arrived from Asia Minor in the 1920s.

This magnificent neoclassical mansion with caryatids embellishing the roof is on Kyrristou Street in the heart of Plaka, the old town. It probably dates from around 1890.

All this had been digested and harmoniously absorbed by the time Athens greeted its visitors for the 2004 Olympic Games. The Games were a milestone in the recent history of Athens. As they do for every Olympic host city, they furnished a powerful incentive to speed up processes and galvanise trends. And they achieved something unheard of in the city's history—they imbued its citizens with civic pride and the belief that Athens would move forward.

The alteration in Athens's self-perception came unexpectedly after the fall of the Soviet bloc. I want to emphasise this because perhaps not enough thought has been given to how profoundly the pace of cities has changed, not so much with population movements, which are in themselves of decisive importance, but with shifting psychological boundaries. Since 1990, Athens, like other cities near the borders of the former Soviet bloc and which for decades had seen itself as belonging to the cultural, political and economic periphery, has had to redefine itself completely. Having had to adjust to the new international environment in the 1990s, with the fall of the Berlin Wall, the war in the former Yugoslavia, and new borders in Europe, Athens gradually began to perceive itself as a centre—not only because it was a capital in the euro zone, but also because its requirements, capabilities and ambitions had changed.

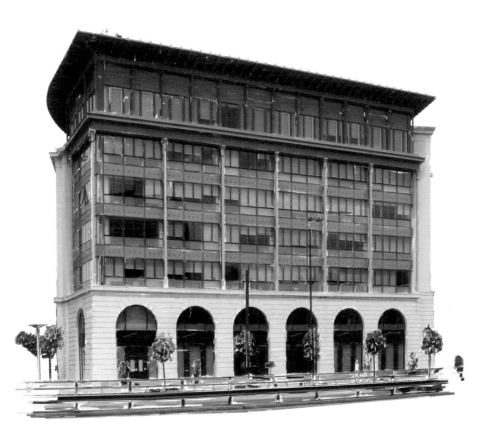

The new Group Head Offices of the InterAmerican Insurance Co. on Syngrou Avenue is a fine example of the glass-and-metal modern office architecture which is to be found north and south of the city centre. It was designed by London-based architect Demetri Porphyrios and built between 2000 and 2003.

It is evident to all that Athens has undergone a renaissance, returning to the natural embrace of the Balkans and the Black Sea, areas that had an extremely vigorous Greek presence until World War II. But relations with Turkey, which have improved considerably and which have had an effect on how Athenians think about the Turks, have also changed the psychological climate in Athens: Greece seems to have toned down the once formidable patriotic right wing and raised the banner of cosmopolitanism.

Since 1990, this altered psychological climate in Western Europe, the Balkans and the Mediterranean has imposed a new role on Athens. The Greek capital, which is three and a half hours from London and Paris and less than two hours from Rome by plane, has always been seen as a city on the edge of Europe—far enough away for a city break of a few days, but rather unfamiliar and probably too disorganised for relaxing holidays.

The challenge for the new Athens is to become an attractive destination and this is slowly being achieved. The city centre has been revitalised and many historic buildings have been refurbished, restoring something of the lost neoclassical charm of the nineteenth century. New buildings designed by Santiago Calatrava, Mario Botta and Demetri Porphyrios have made architecture a subject of public discourse, and for the first time in recent years the Athenian press has dealt extensively with the architectural revamping of the city.

Sprucing up the city's public spaces, squares and gardens has become a public issue, because, as has always been the case in Greece, the city is the realm of private initiative. Sometimes individualism is so rampant in Athens that you wonder if we are back in the days when laissez-faire capitalism ruled, more than 100 years ago. Greeks are individualists to

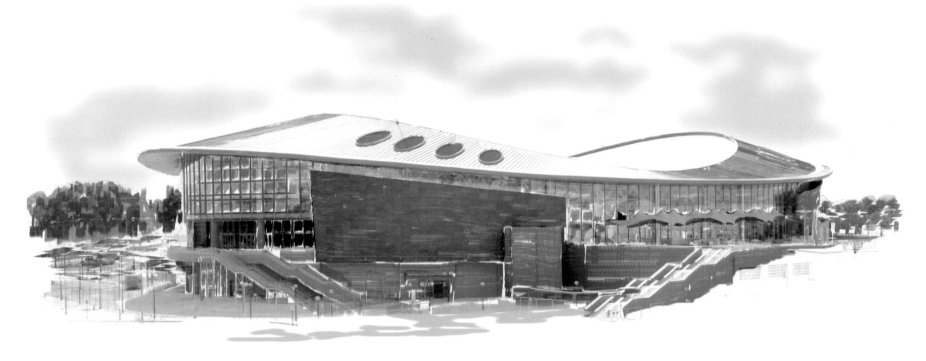

The Sports Pavilion in the Faliro Coastal Olympic Complex was built for the 2004 Athens Olympics according to a design by architectural firm Thymio Papayannis. The 8,100-seat stadium was the venue for taekwondo and handball contests during the Games.

the core and are slowly learning to function as citizens. Athens is a city that has glorified private enterprise, even at the expense of its historic heritage. Like many German cities, Athens was rebuilt in the 1950s, although war damage to buildings here was limited. The city and its inhabitants are part of a new, free, but harsh, international environment. Athens, now a major metropolis, has to create its own synthesis of Greek, Balkan and Mediterranean culture, and the city at moments bears almost imperceptible traces of some of its geographical neighbours across the Adriatic and the Aegean.

Yet though it is a large city and a popular tourist destination for mil-lions of Britons, Germans, French and Italians, Athens is above all a city imbued with the spirit of Romanticism.

At least that is what I like to think every spring as I inhale the intoxicating fragrance of bitter orange trees in blossom in a city that has so often been criticised (unfairly at times) for its pollution; as I stroll the streets in summer when the city is boiling hot and the pine trees give off the heady aroma of resin; in autumn, when dusk tints the surround-ing mountain peaks with violet and orange; and in winter, when the Halcyon days—that mid-January respite from a brief, though sometimes bitterly cold winter—bathe the sea and sky in light.

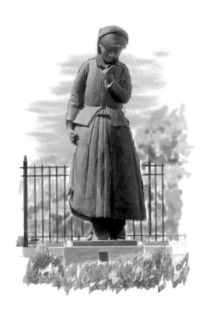

The bronze "H Mana" or The Mother by Christos Kapralos was installed in the grounds of the Parliament in May 2003.

The Heart of Modern Athens

Athens is a vast city. Seen from above, it is an immense modern urban complex, very densely built, with low hills acting as compass points. Sprawling all the way to the sea, the capital of Greece is a city that entered the modern world only in the nineteenth century and experienced enormous expansion in the twentieth.

Despite its size and its population of four million, Athens has a historic centre which is easy to negotiate on foot, and which encompasses the great monuments of classical antiquity as well as the modern city. Side by side and interdependent, the ancient and modern towns function as a single living organism. With its boisterous crowds ever-present, Athens is a noisy but exciting city, very hot in summer, with short though often cold winters.

Syntagma Square is the centre of Athens, dominated by the Parliament. From the square, the main roads radiate towards Plaka, the old town, by way of the main shopping street, Ermou; towards Omonia (an old square that has seen better days); up Vasilissis Sofias to the Hilton and the Megaron Mousikis or Athens Concert Hall; and west and south to the National Gardens and Syngrou Avenue, the grand boulevard that leads to the sea and the port of Piraeus.

In the centre of modern Athens, a mixture of nineteenth-century neoclassical and twentieth-century buildings present an aesthetic mix from which the city's special personality arises. The Acropolis and Lycabettus, Athens's two historic hills, are landmarks that defined the city's boundaries until 1900. Even today, they recall the classical landscape of Athens.

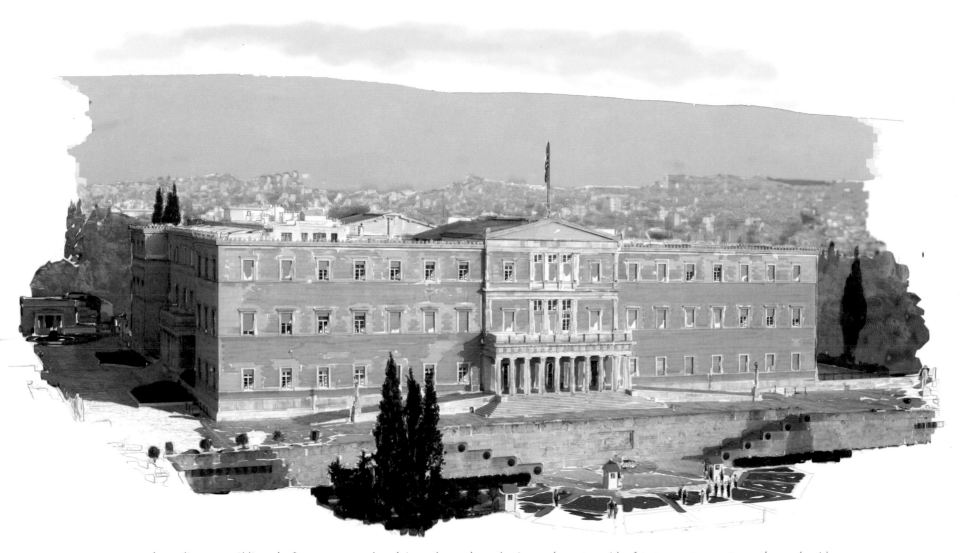

The Parliament Building, the first monumental work in modern Athens, dominates the eastern side of Syntagma Square. It was the royal residence from 1843 until fire gutted it on Christmas Eve 1909. The building was used to house 10,000 refugees in 1923 after the Smyrna catastrophe, underwent five years of reconstruction, and was finally occupied by Parliament in July 1935.

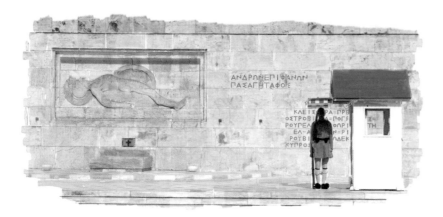

The Monument to the Unknown Soldier is guarded night and day by members of the Presidential Guard called "Evzoni". The Greek text in the illustration translates as "Illustrious men have the whole earth as their memorial". It is from the funeral oration of Pericles, given in 430 BC at Kerameikos (page 57).

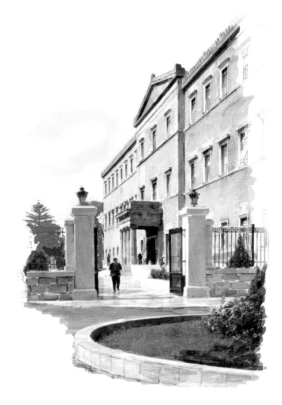

The marble Doric-style portico on the east side of the Parliament building is the Member's entrance.

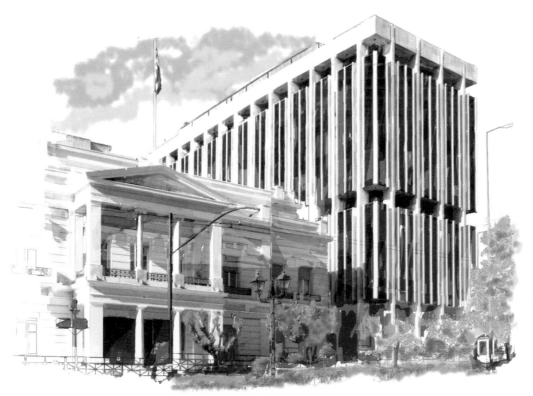

A dramatic combination of neoclassical and modern architecture on Vasilissis Sofias Avenue houses the Ministry of Foreign Affairs. The mansion on the left, completed in 1873, was formerly the home of Andreas Syngrou. In 1985, it was connected to the modern building which opened in 1978.

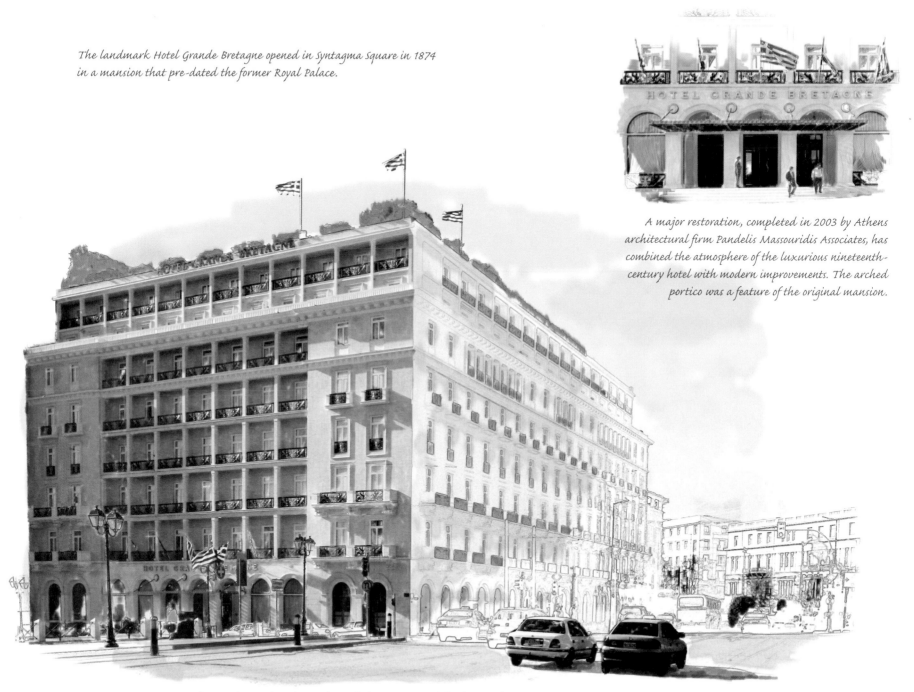

The landmark Hotel Grande Bretagne opened in Syntagma Square in 1874
in a mansion that pre-dated the former Royal Palace.

A major restoration, completed in 2003 by Athens
architectural firm Pandelis Massouridis Associates, has
combined the atmosphere of the luxurious nineteenth-
century hotel with modern improvements. The arched
portico was a feature of the original mansion.

In 1896, the Hotel Grande Bretagne housed the organisers of the first modern Olympics, and during World War II
was successively the headquarters for Greek, German and British forces.

Syntagma is the largest station in Athens's ultra-modern metro system. Each station has its own character. In many of them, archaeological finds, revealed during excavations, and modern art are displayed.

The poster standards, known as "Pisas", erected throughout Athens by the municipality in the 1990s, have become part of the landscape.

Syntagma (Constitution) Square got its name when, in March 1844, King Otto swore, from his balcony overlooking the square, to support a new constitution. The latest of many changes over the years was an extensive remodelling before the 2004 Olympics. The five-star King George II Hotel can be seen in the rear of the illustration.

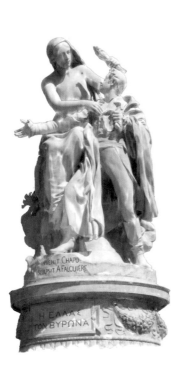

Lord Byron, the most famous of British philhellenes, stayed in Psyrri in 1809 and in Plaka from 1810 to 1811. Widely commemorated in Athens, it is said of him: "He loved Greece and Greece still loves him." Sculptor Falguiere's 1898 romantic monument, sited opposite St. Paul's Church, shows Hellas crowning Byron with a wreath.

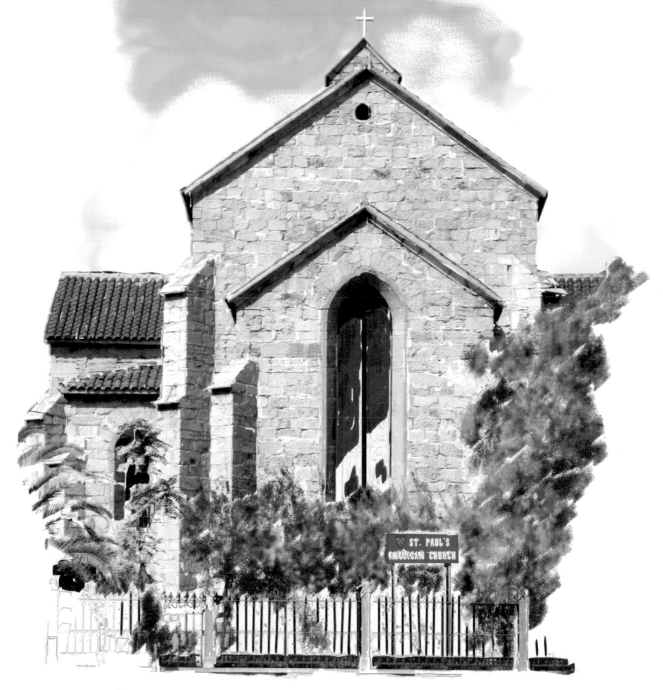

Inscriptions on the windows and walls of St. Paul's, the Anglican church of Athens, commemorate a number of Britons — from those who fought in the Greek War of Independence, such as Richard Church who later became a member of the Greek Parliament, to Brigadier Stephen Saunders, the Military Attaché murdered by terrorists in 2000.

This magnificent mansion was originally the home of German archaeologist and philhellene Heinrich Schliemann, who discovered Troy. It housed the Supreme Court from 1927 until 1994, when it was occupied by the Numismatic Museum, founded in 1834.

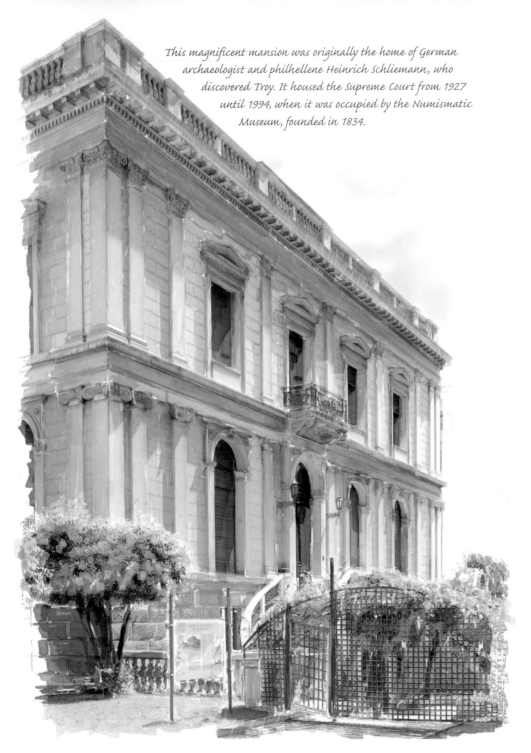

The street that isn't. Although officially twice named after former Prime Minister Eleftherios Venizelos (1864–1936), and signposted accordingly, this major avenue is still known to all Athenians as Panepistimiou (University) Street, the name it held for 100 years from 1884.

The view on the left shows the curving double stairway to the main entrance, seen from the rear garden which is entered through these ornately-decorated iron gates.

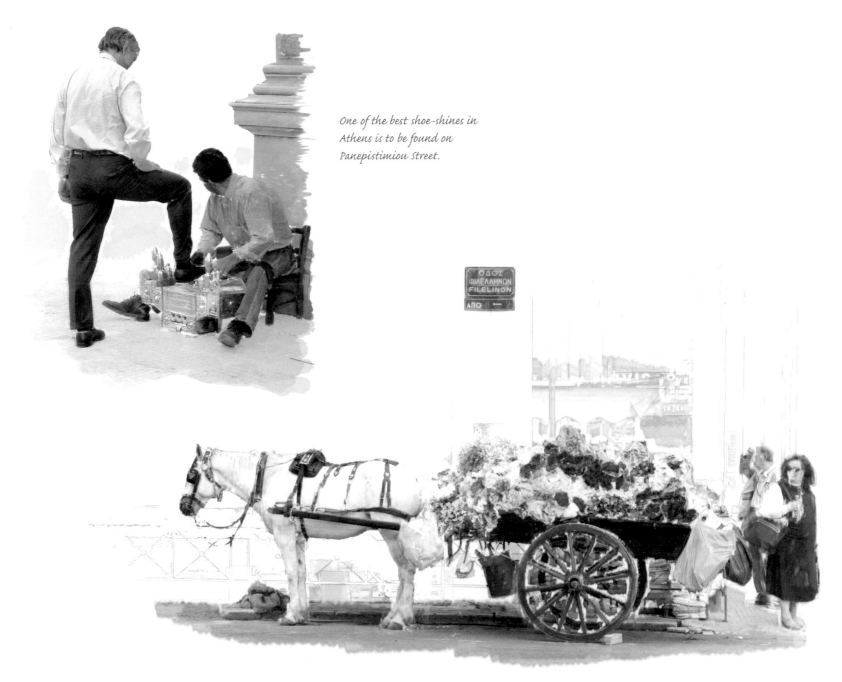

One of the best shoe-shines in Athens is to be found on Panepistimiou Street.

Just off the modern bustle of Syntagma Square, on Philellinon Street, is a reminder of more colourful and less hurried days — a flower seller with his horse-drawn cart is seen here plying his wares.

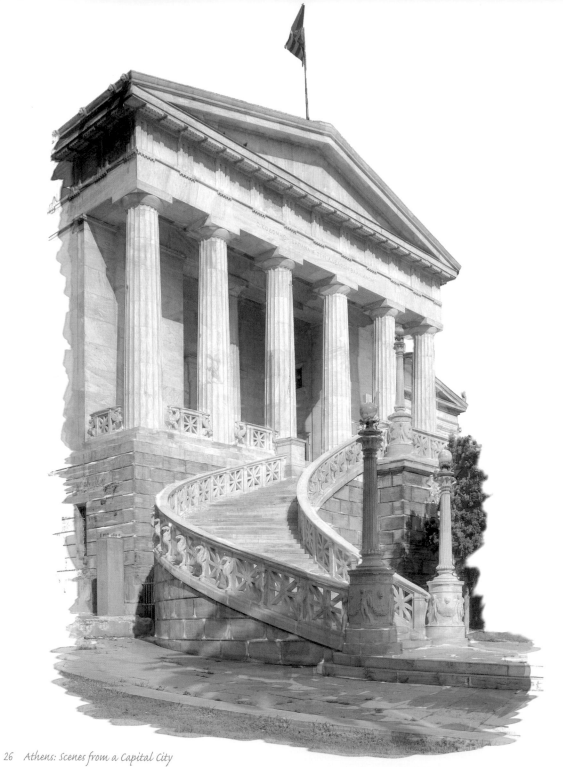

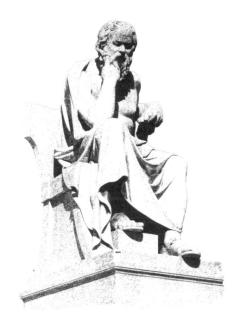

Leonidas Drossis's statues of those
guardians of knowledge, Socrates (above)
and Plato, flank the main entrance of
the Academy (opposite).

Theophilus Hansen's National Library, the last built of the
"trilogy" of Athens, is reminiscent of a late fifth century
temple, such as the Hephaisteion in the Agora (page 54),
with two smaller temples as wings. The library's collection
comprises over three million books and 4,500 manuscripts
dating back to the eighth century.

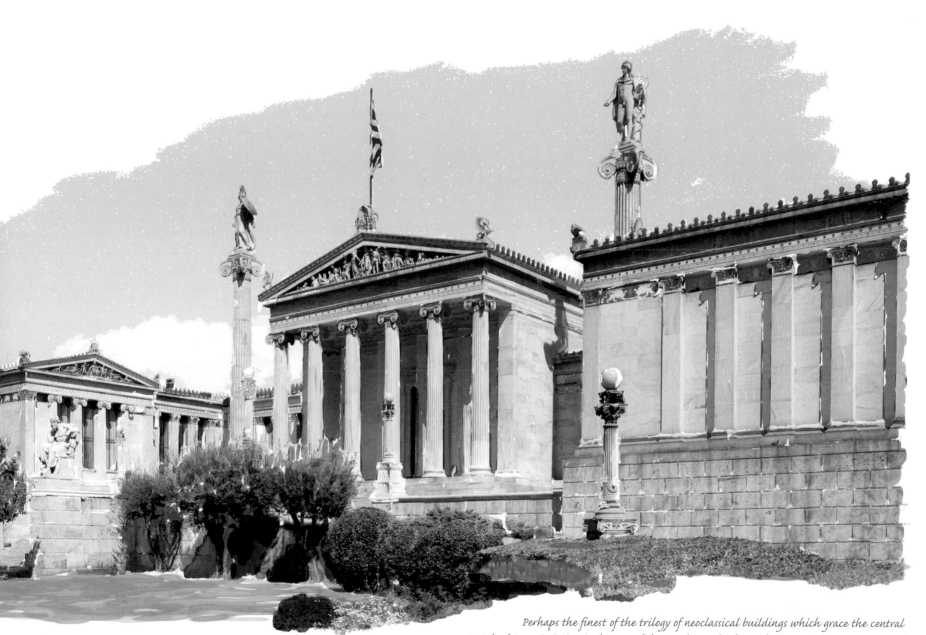

Perhaps the finest of the trilogy of neoclassical buildings which grace the central stretch of Panepistimiou is the seat of the Academy of Athens, the pre-eminent institution of learning and culture in Greece. Each year the Academy, "The Immortals", makes awards to institutions and individuals whose efforts have contributed to the good of the country.

The colourful portico of the University includes frescoes, painted by Eduardo Lebiedzky, representing Greek art, education and mythology. Officially, the university is named after Count Ioannis Kapodistrias who founded it in the Kleanthis house in Plaka (page 42) in 1837.

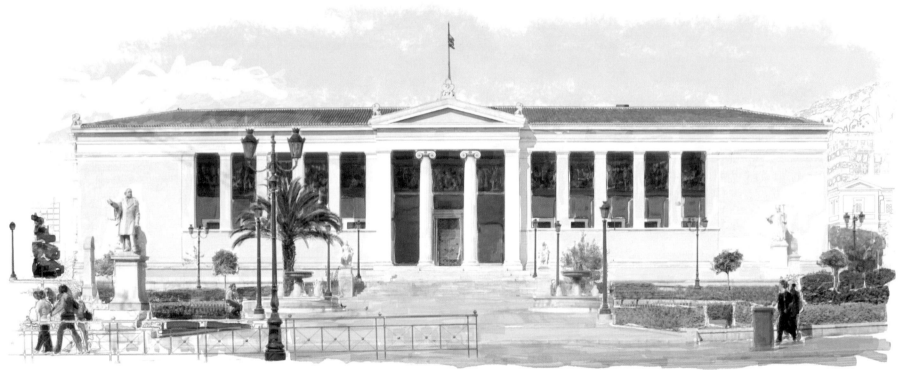

The gracefully-restrained University building on Panepistimiou was the centrepiece of the plan to create an axis for cultural and educational activity in the new capital city and was the first-built of the Athenian trilogy. Today, the faculties of the University are scattered around Athens and its outskirts, and this building is used for administration and special events.

A marble relief of the crest of Pope Leo XIII, in a wall behind the Catholic Cathedral of St. Denis, was previously at the gate of a seminary founded on Sina Street by the Pope in 1901.

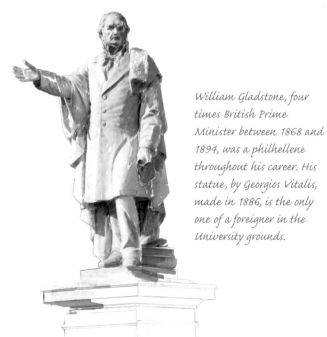

William Gladstone, four times British Prime Minister between 1868 and 1894, was a philhellene throughout his career. His statue, by Georgios Vitalis, made in 1886, is the only one of a foreigner in the University grounds.

The Rallis House on Panepistimiou is one of Athens's oldest post-independence houses. Once the residence of Prime Minister Dimitrios Rallis, it was later put to commercial use and deteriorated sadly. Fortunately, it was preserved when the glass-sheathed building by Jason Rizos was built round it. It was renovated in 1998.

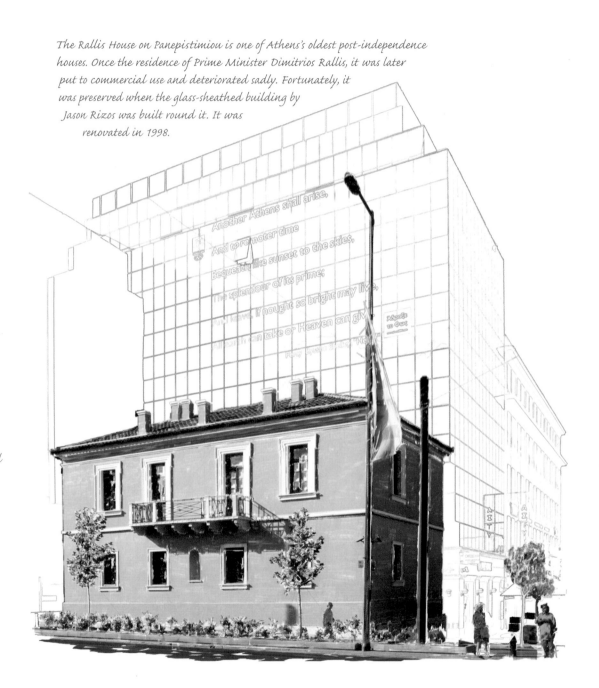

The quiet neoclassical simplicity of the City of Athens Cultural Centre on Akadimias Street, seen here with Mount Lycabettus behind, speaks to its origins as the first municipal hospital. The building houses the Museum of the Theatre, a reminder that drama was born here in Athens where, today, there are some 120 theatres.

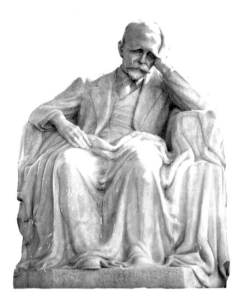

Vassos Falireas's 1975 statue of Kostis Palamas, one of Greece's great poets, has a place of honour outside the Cultural Centre.

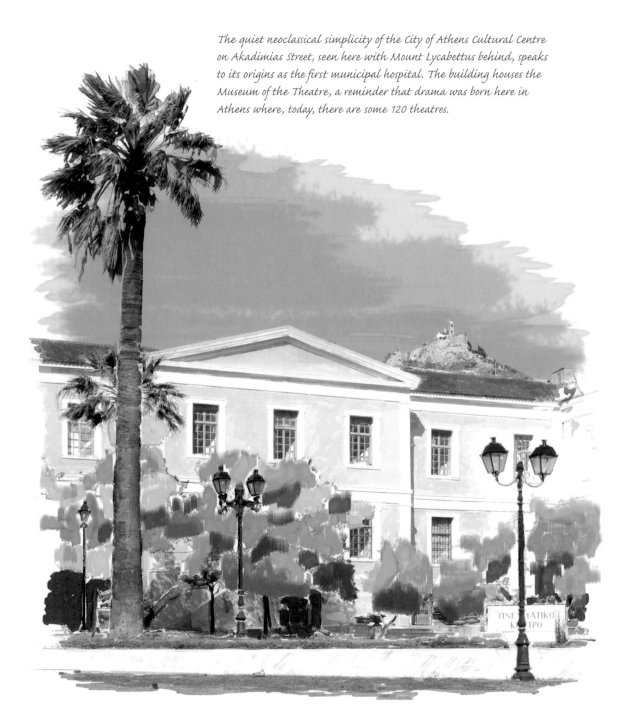

The Monument of the Resistance, sculptor Giorgos Nikolaidis's 1991 commemoration of the University community who died resisting the German occupation, is framed by the pink of the Kostis Palamas building.

Corner towers crowned with silver cupolas distinguish the Arsakeion Extension. The interior contains a marvellous glass-roofed arcade of book and music shops, often called the Orpheus Arcade after a cinema built into the block in 1937.

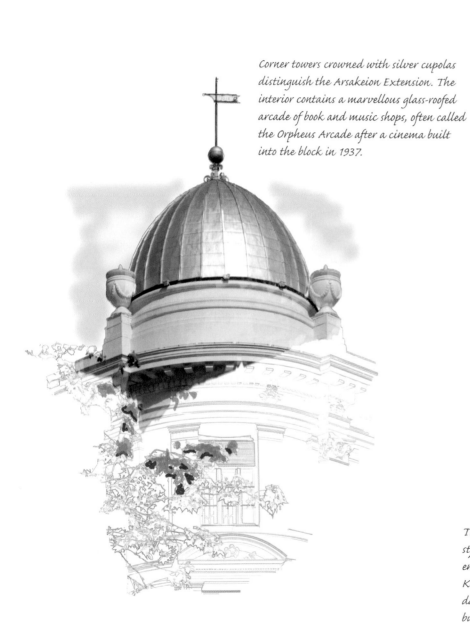

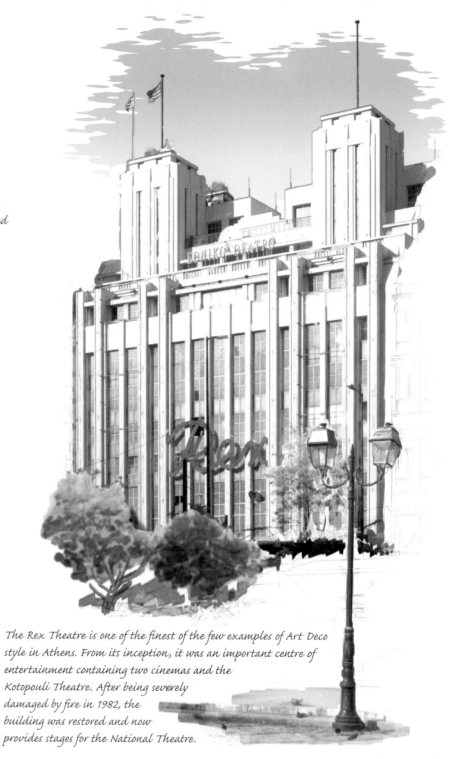

The Rex Theatre is one of the finest of the few examples of Art Deco style in Athens. From its inception, it was an important centre of entertainment containing two cinemas and the Kotopouli Theatre. After being severely damaged by fire in 1982, the building was restored and now provides stages for the National Theatre.

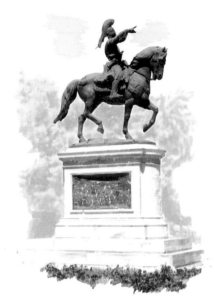

The National Historical Museum was built to house parliament, which sat here from 1875 to 1935. A casino owner, angry at the Government's decision to curtail gambling, assassinated Prime Minister Theodore Deliyiannis on these steps, on May 31, 1905. The museum's eclectic collection of paintings, weapons, costumes and maps is particularly strong on the formation of the modern Greek state.

The bronze statue in front of the National Historical Museum is of Theodoros Kolokotronis, a hero of the Greek War of Independence. It is a 1904 copy of that by Lazaros Sochos in Nafplion, the Greek capital before Athens was chosen.

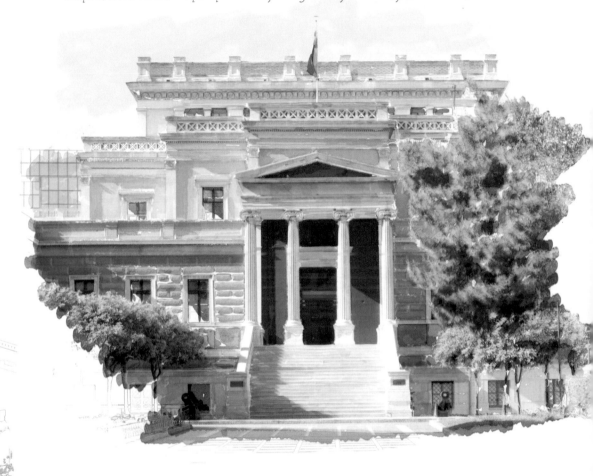

The landmark Army Share Fund Mansion, completed in 1938, covers a whole block between Panepistimiou and Stadiou Streets, on what was formerly the site of the royal stables. The entire block was renovated and reopened in 2005 as the up-market City Link Shopping Center.

Klafthmonos (Lamentation) Square got its name from the time when civil servants were political appointees. On a change of government, the now-jobless workers would gather in the square (which then housed the Ministry of Finance) to bewail their misfortune.

"National Reconciliation", a 1988 bronze by Vassilis Doropoulos, consists of three women whose joined arms symbolise the end of an era of political divisions in Greece.

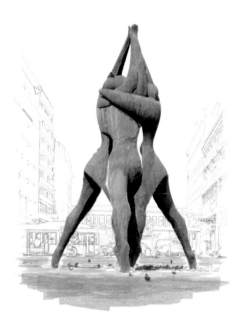

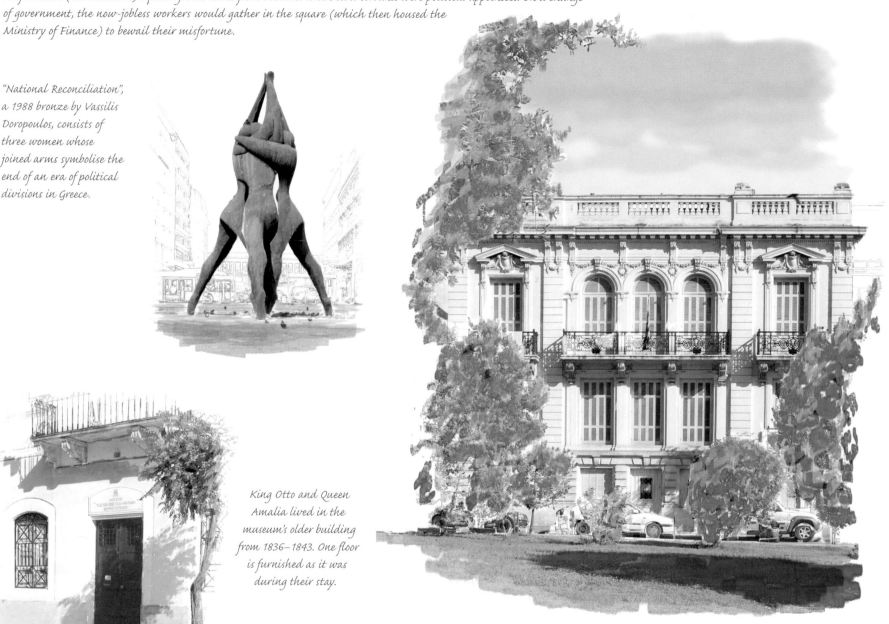

King Otto and Queen Amalia lived in the museum's older building from 1836–1843. One floor is furnished as it was during their stay.

The Museum of the City of Athens occupies two of the new capital's earliest buildings. Founded by the late Lambros Eftaxias, an avid collector, a lover of Athens, and a sometime Cabinet Minister, the museum's superb collections focus on the post-Independence history of Athens.

A square of many names. Kotzia Square, named after a mayor of Athens, is officially named National Resistance Square (since 1977, to commemorate World War II resistance) but is also known as Dimarkheion Square after the City Hall. It was originally called Ludwig Square in honour of King Otto's father, but was renamed New Theatre Square when the king was deposed (a Municipal Theatre designed by Ernst Ziller occupied much of the square from 1888–1939). It became Konstantinos Kotzia Square, the name which seems to have stuck, in the 1930s.

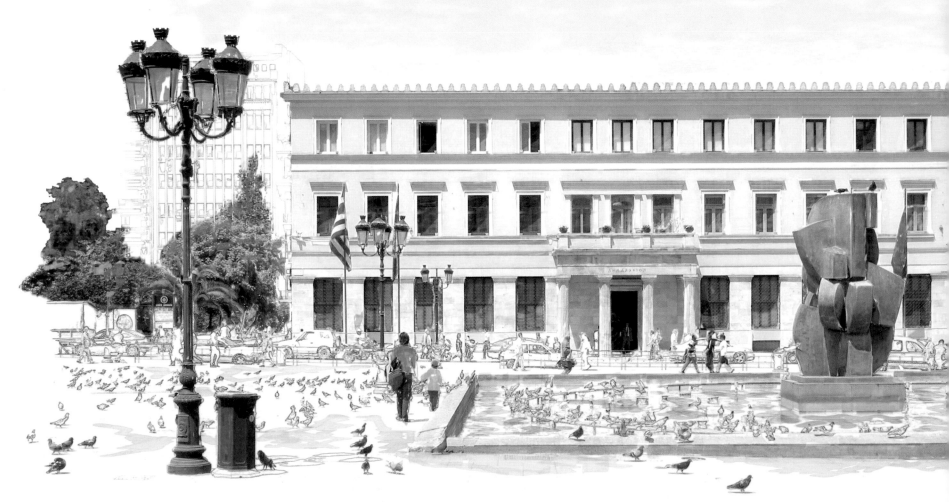

City Hall, the seat of Athens's government, is also the venue for civil marriages. The abstract bronze in the centre of the fountain is "Theseus" by Sophia Vari.

An organic grinder, who sports a range of brightly-coloured jackets, is a cheering sight on Kotzia Square.

The National Bank of Greece's modern Administration building (centre) was built over remains of the ancient city wall. These have been preserved within the building and are visible from the street. The former Melas mansion (right) houses exhibition space and administrative offices for the bank.

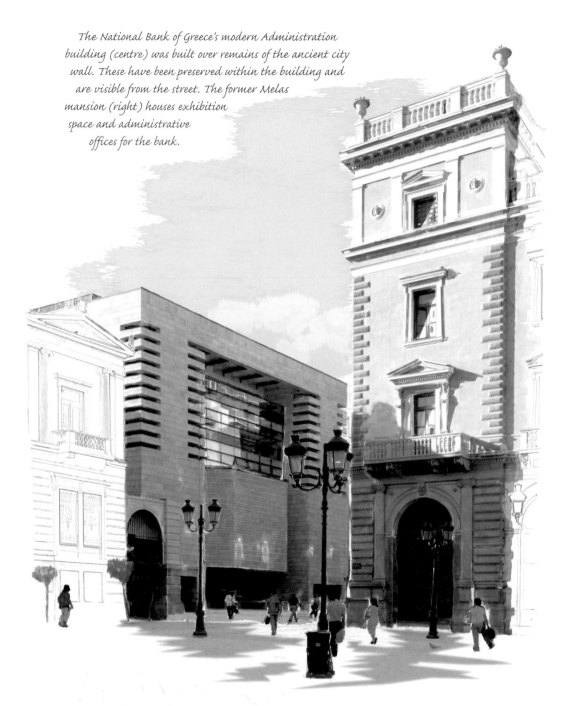

Yellow telephone booths are part of the city's furniture.

Omonia Square, once the hotel and entertainment centre of the city, became congested and declined in the 1970s and 1980s. It has recently begun to revive and attract new investments including the huge Hondos department store, an early 1990s development on the shell of the former Omonia Hotel.

Trolley buses are still a feature of Omonia Square, which has been a transport hub since the rail from Piraeus was extended to here in 1895, and it became the terminal for the first electricity-driven trams in 1908.

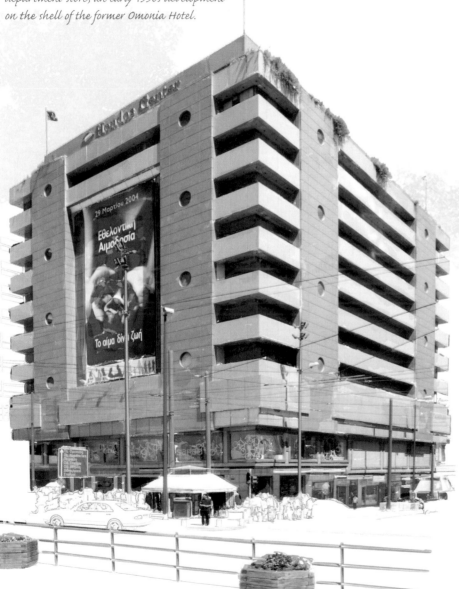

The Hotel Megas Alexandros (Alexander the Great), designed by Ernst Ziller in 1899 and recently restored, is a reminder of the neoclassical past of this constantly changing area.

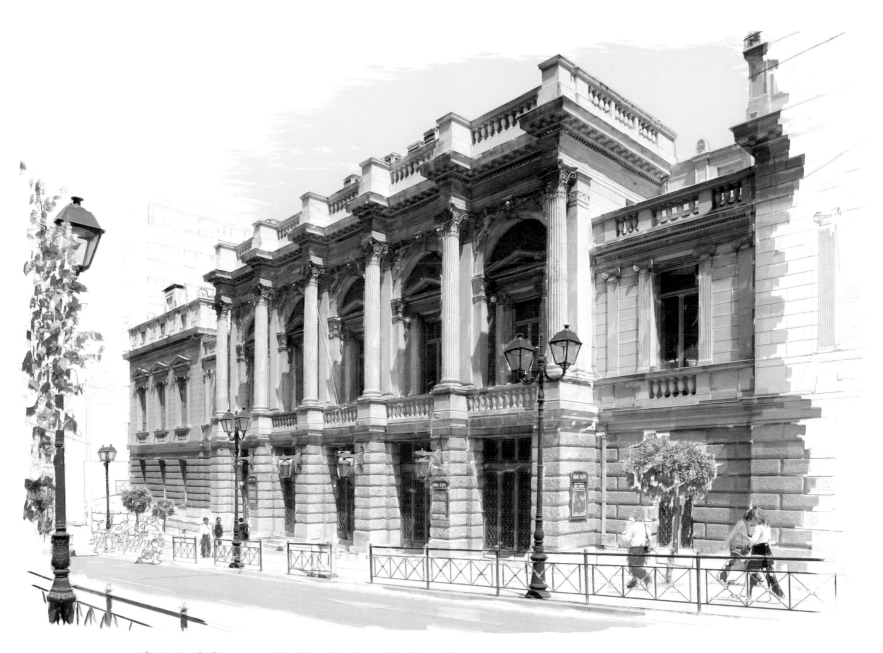

The National Theatre was originally used exclusively by the royal court, and opened as the Royal Theatre. The name was changed in 1931. The performances staged here range from classical to modern drama, but the emphasis is on ancient theatre. The National Theatre has five stages, three in this building and two more in the Rex Theatre (page 31).

The Acropolis and the Old Town

Athens would not be Athens without the Acropolis and the monuments of classical antiquity. The Acropolis is to Athens what citadels are to many cities in Central and Western Europe. On the Acropolis, the Parthenon, which is the symbol of Athens, has been undergoing painstaking restoration for at least 25 years, and it will take quite a few more years before the scaffolding is completely removed from parts of the monument.

All around the rock of the Acropolis, which offers a unique view of the city, the ancient city co-exists with parts of Byzantine and neoclassical Athens. Monuments such as the temple of Hephaestus in Thiseion, the best-preserved ancient temple in the whole of Athens; the Ancient Agora; the beautiful buildings bequeathed by Roman Emperor Hadrian to his favourite city such as the gate and the library

that bear his name; and the Odeion of Herod Atticus, a Roman building that has been home to the Athens festival for 50 years, all mingle with Byzantine churches that are 800–1,000 years old, as well as nineteenth-century neoclassical houses.

Plaka, the old town, is a quiet precinct that separates the antiquities from the hustle and bustle of the modern city. One of the most colourful and romantic corners of Athens, Plaka has charming little houses with tiled roofs set amidst flower-filled courtyards and narrow streets. More than 100 years ago, it was renowned for the romantic songs, known as "cantades", which were sung here. Then, love-struck youths would serenade their sweethearts beneath their windows, while strumming a guitar. Today, Plaka is full of restaurants, tavernas and tourist shops—a little town inside the big city.

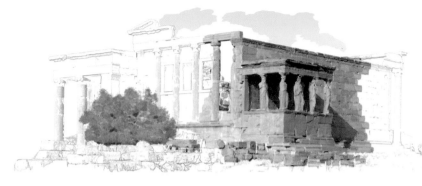

The striking south portico of the Erechtheion is known as the Porch of the Caryatids from the six female figures supporting the marble roof.

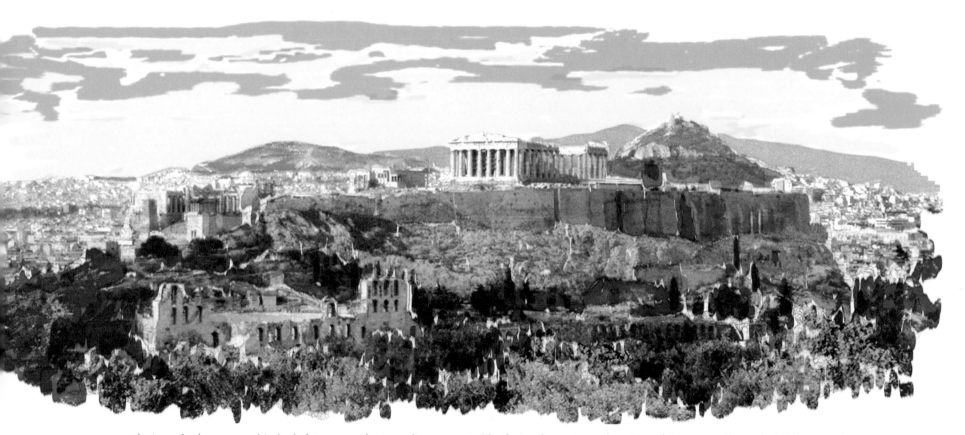

The icon of Athens — and indeed of Greece — the Acropolis, surmounted by the Parthenon is seen here from Philopappus Hill. In the left foreground is the Theatre of Herod Atticus. Lycabettus, surrounded by the modern residential neighbourhoods, stands behind. The walls fortifying the southern slope, visible here, were built following the conquest and destruction of the Acropolis by the Persians in 480 BC.

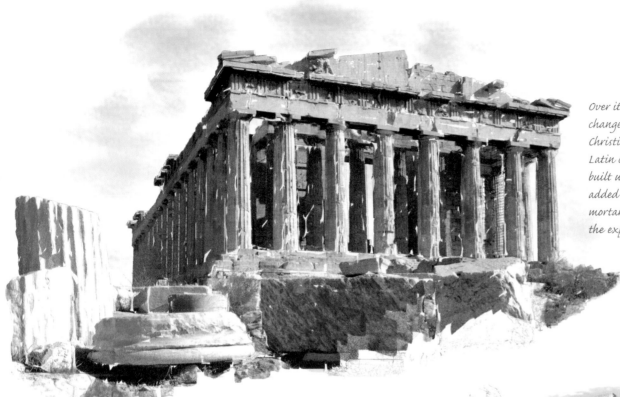

Over its 2,500-year history, the Parthenon saw many changes. In the sixth century, the temple became a Christian church and for 250 years from 1204 it was a Latin cathedral. In the Ottoman period, a mosque was built within its walls, and a bell tower that had been added earlier became a minaret. In 1687, a Venetian mortar hit a Turkish powder magazine within and the explosion split the structure in two.

The Theatre of Dionysos was the birthplace of drama in the fifth century BC. A front row of Pentelic marble thrones for priests and dignitaries were a later addition.

The Odeion of Herod Atticus is a typical Roman theatre that originally seated 5,000 to 6,000 people. It was finished with white marble seats and once had a tile-covered roof. The theatre was restored in the 1950s and is now the venue for the annual Athens Festival.

After the construction of the Olympieion, the Athenians honoured the emperor Hadrian with this symbolic gateway. On the facade facing the Acropolis is carved, "This is Athens, the ancient city of Theseus", and on the opposite side, "This is the city of Hadrian and not of Theseus."

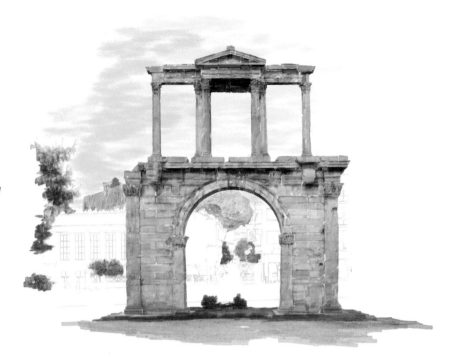

When the Olympieion, the temple dedicated to Olympian Zeus, was completed in AD 130, statues of Zeus and of Hadrian, the emperor who ordered it built, stood within its 140 columns. Earthquakes and the use of the columns for building materials took their toll over the next 2,000 years and today only 15 columns still stand. In this view, the Acropolis is on the right.

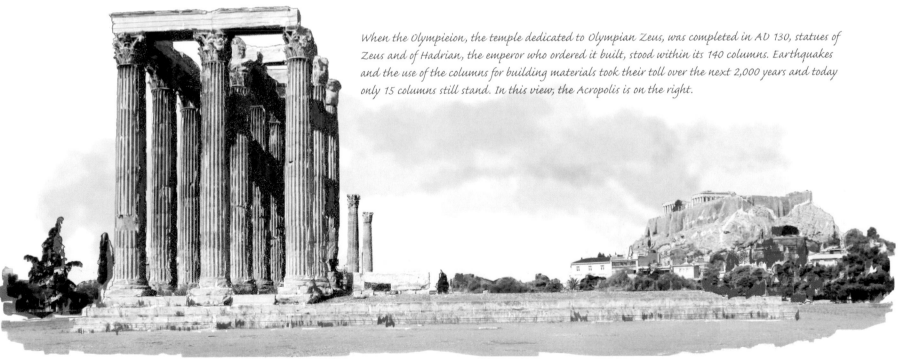

In Plaka, uniquely, buildings and monuments from over 2,000 years of Athens's history stand cheek by jowl — from the classical to the Roman, Byzantine and Turkish eras, in traditional, neoclassical and modern styles.

Lysiou Street in Plaka is named after an ancient Greek orator and speechwriter.

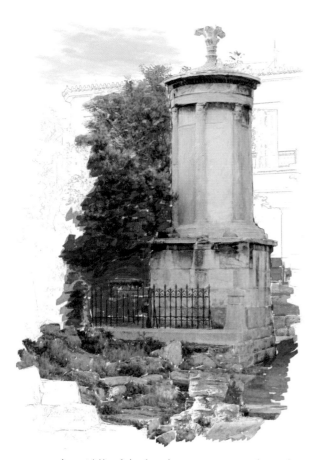

In the middle of the fourth century BC in Athens, the birthplace of theatre, a drama contest was held each March. The Monument of Lysikrates is named after the sponsor whose chorus won in 334 BC, and who built the monument.

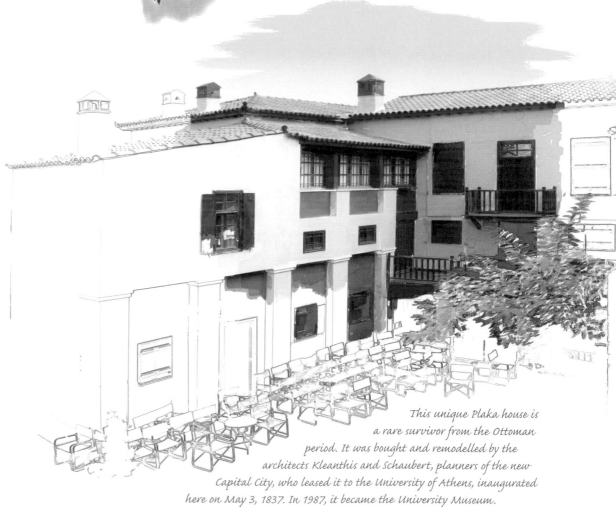

This unique Plaka house is a rare survivor from the Ottoman period. It was bought and remodelled by the architects Kleanthis and Schaubert, planners of the new Capital City, who leased it to the University of Athens, inaugurated here on May 3, 1837. In 1987, it became the University Museum.

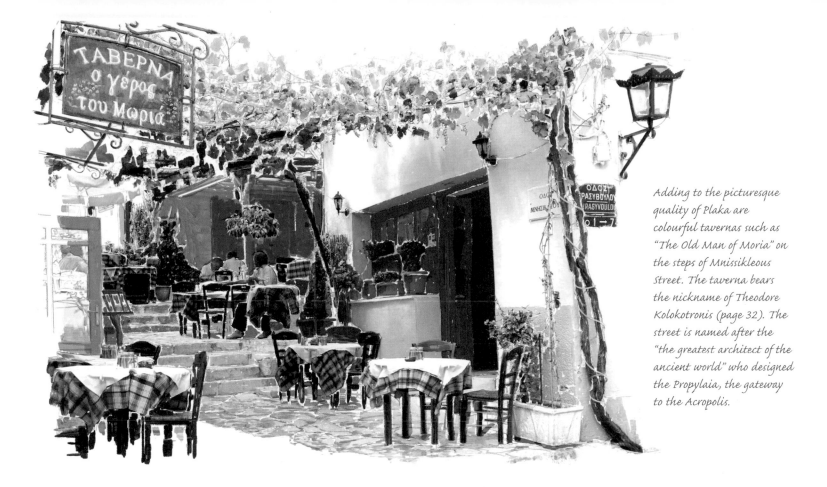

Adding to the picturesque quality of Plaka are colourful tavernas such as "The Old Man of Moria" on the steps of Mnissikleous Street. The taverna bears the nickname of Theodore Kolokotronis (page 32). The street is named after the "the greatest architect of the ancient world" who designed the Propylaia, the gateway to the Acropolis.

Hanging on the north slope of the Acropolis is a huddle of small whitewashed houses. This is Anaphiotika, settled in the 1860s by Cycladic islanders who migrated to Athens as builders and established homes in their island vernacular. A church serving the settlement is the 17th-century St. George of the Rock, shown here.

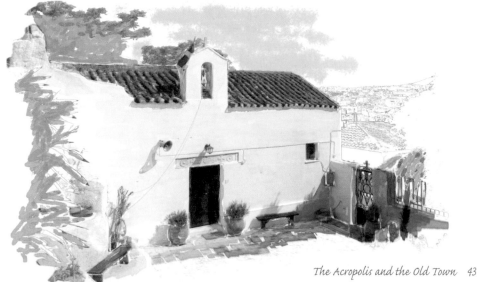

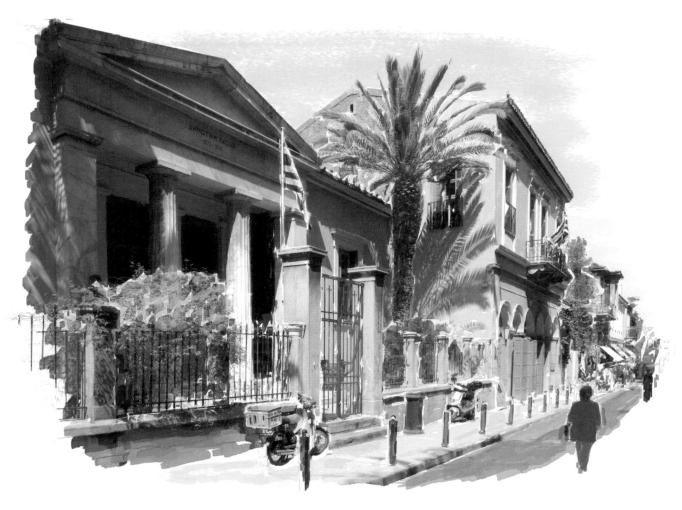

In the last 25 years, after becoming dilapidated and raucous following World War II, Plaka has undergone a major renewal and its many fine residences have been enhanced by new museums, good restaurants and well-exhibited archaeological sites. This quiet corner is on Andokithou Street.

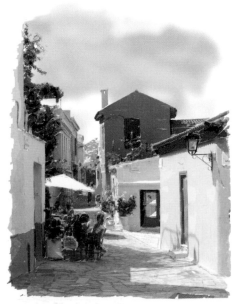

Adrianou Street, named after a Roman soldier and intellectual who contributed to the completion of Olympieion, runs right through Plaka. It is a road of many moods. Here, at the corner of Flessa Street, is the public primary school, built between 1874 and 1875, to a classical revival design by Panagiotis Kalkos.

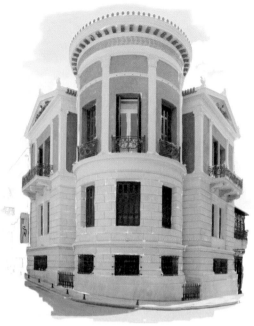

The corner rotunda makes this one of the most elegant neoclassical houses in Athens. Dating from 1904, it is now part of the Frissiras Museum of Contemporary European Painting founded in 2000 to house the collection of founder Vlassis Frissiras.

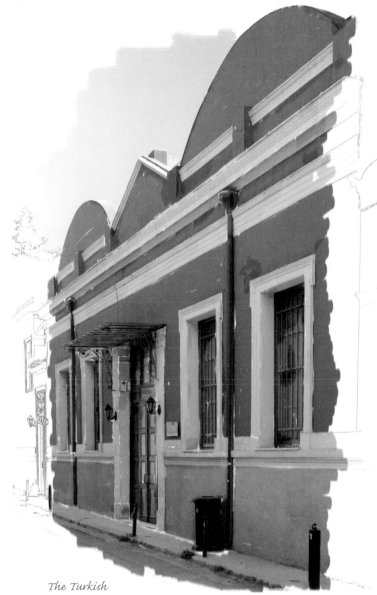

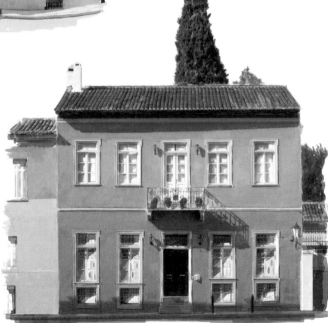

This stunning house in "Otto's style", which forms a bridge between traditional forms and the neoclassical, was built on Kyrristou Street in 1843 by the Varthis brothers, Diamantis and Michael, boat-owners from Hydra. Their small Ottoman-period house on the plot is incorporated into the rear.

The Turkish Bath on Kyrristou Street — the bath of Abit Efendi — the last remaining public bath house of the Ottoman period, continued to function as such until 1965. Recently restored, it is now part of the Museum of Greek Folk Art.

The eight sides of the Tower of the Winds, a unique marble tower by the Roman market, are aligned with the principal points of the compass. Each face has a relief portraying the wind blowing from that direction, thus its popular name.

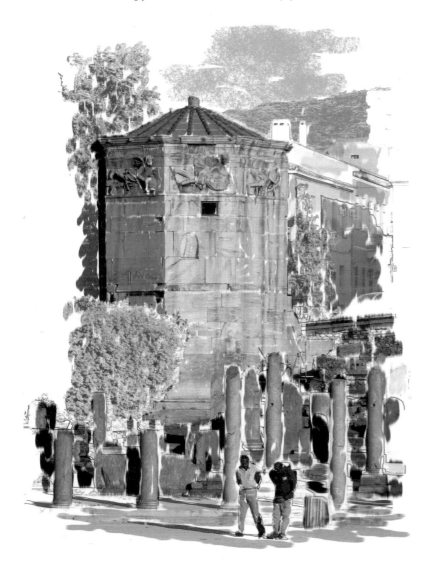

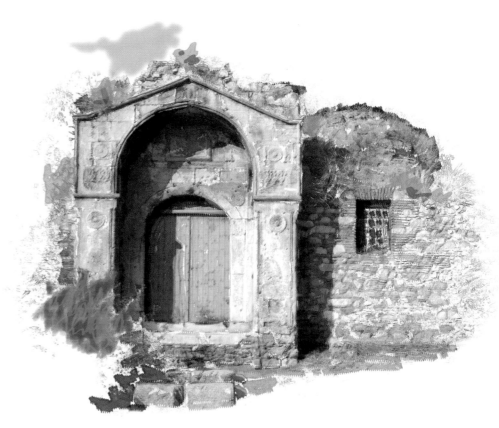

This gateway and a cupola are all that remain of a Turkish seminary or Medresse founded in 1721 with rooms arranged around a colonnaded courtyard. The gateway was topped by a domed lecture hall and mosque. From late in Turkish rule until 1911, the Medresse served as a prison. The building was demolished in 1919 after it was struck by lightning.

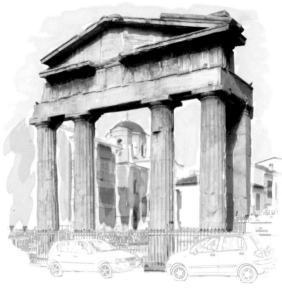

The Doric columns of the gate into the Roman Market stand at its western end at the junction of the colonnaded street which led to the Ancient Agora and the path leading to the Acropolis. The gate, dedicated to the goddess Athena Archegetis (Athena the Leader), was built with funds donated by Julius Caesar and Augustus.

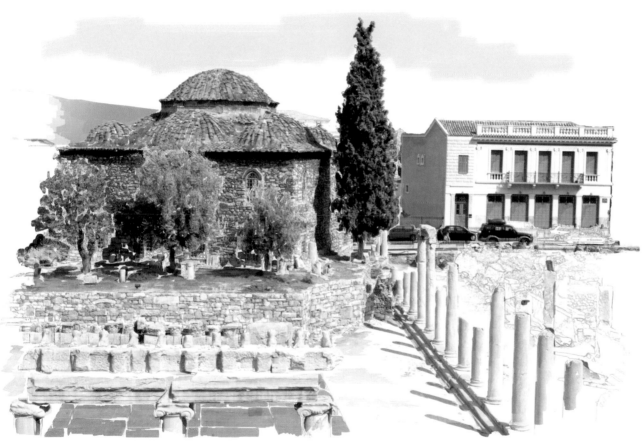

Roman, Turkish, and post-independence neoclassical buildings, as well as 21st-century vehicles, stand side by side in the centre of Plaka. The Roman market place in the foreground, begun by Julius Caesar, was the centre of civic activity for over 200 years. The Fethiye Tzami (Mosque of Victory) in the background (on the left) was built around 1458. Once briefly converted by Venetian occupiers into a Catholic church, it was later used as a school, an army post, a bakery, a prison and a storehouse.

The Monastiraki area gets its name from an extensive convent that, in later Ottoman times, was known as the Great Monastery. After many of its buildings were demolished in the 1800s it became the Little Monastery, or monastiraki, a name then acquired by the square and its surrounds.

The Church of the Virgin Mary (Pantanassa) was built about 1678 on the site of a 10th-century basilica attached to the convent . The belfry was added in 1911.

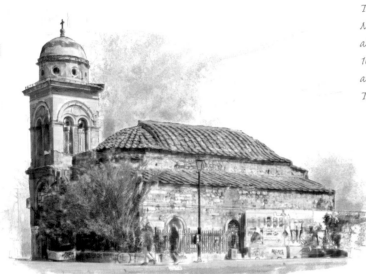

The original painted mihrab (prayer niche) of the mosque is preserved in the delightful Museum of Greek Popular Art.

The Plaka from Monastiraki Square. The Acropolis is between the metro station and the former Mosque of Tzistarakis, now the Museum of Greek Popular Art. Mustafa Aga Tzistarakis was the Ottoman governor of Athens. In 1759, to obtain building material for his mosque, he destroyed one of the columns of the Olympieion, an act that led to his expulsion.

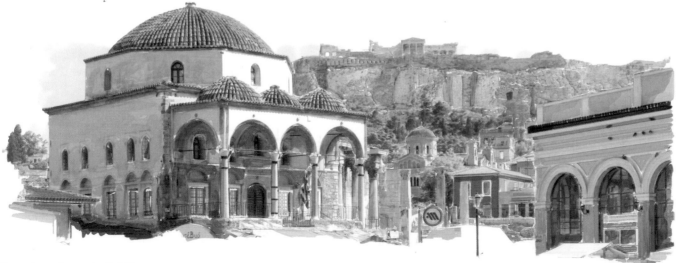

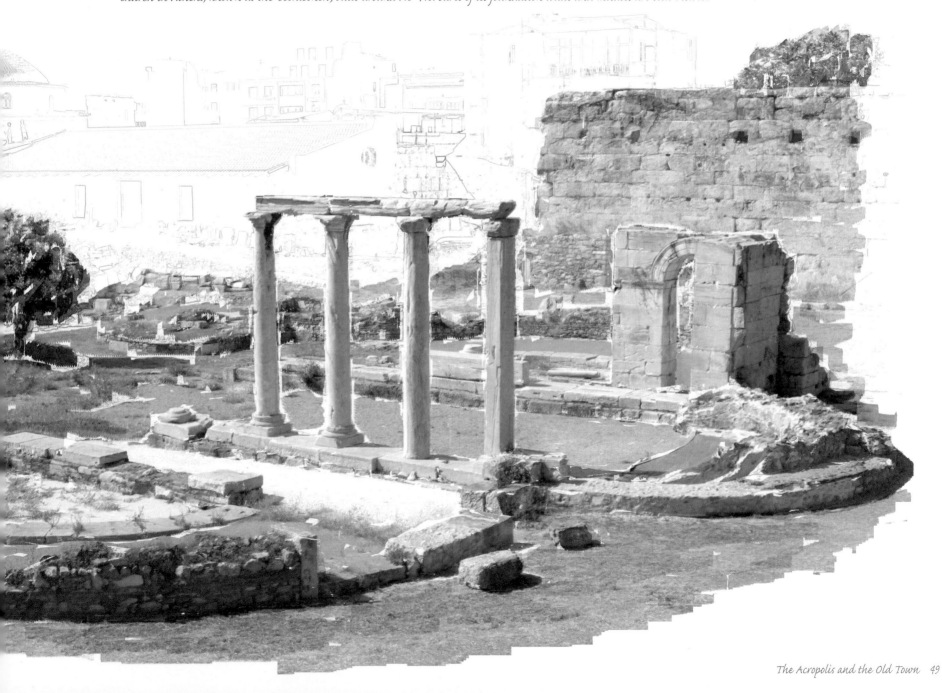

Layers of history. The four columns standing within Hadrian's Library, which was built in AD 132, are from an 11th-century church destroyed when fire gutted the bazaar in1884. It, in turn, had been built within the remains of the earliest Christian church in Athens, known as the Tetraconch, built around AD 410. Parts of its foundation walls and mosaics are still visible.

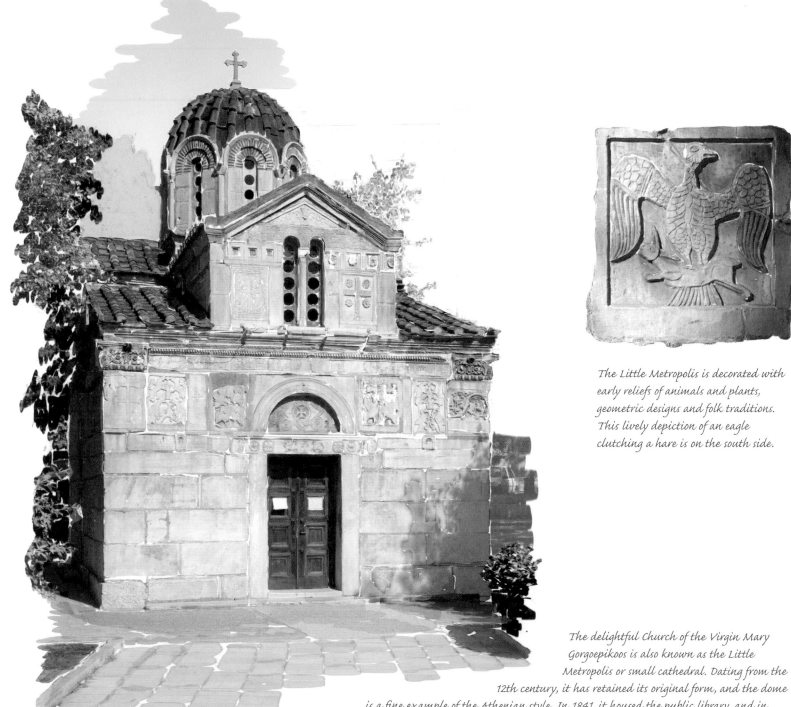

The Little Metropolis is decorated with early reliefs of animals and plants, geometric designs and folk traditions. This lively depiction of an eagle clutching a hare is on the south side.

The delightful Church of the Virgin Mary Gorgoepikoos is also known as the Little Metropolis or small cathedral. Dating from the 12th century, it has retained its original form, and the dome is a fine example of the Athenian style. In 1841, it housed the public library, and in 1863, following the overthrow of King Otto, it was renamed Aghios Eleftherios (St. Freedom).

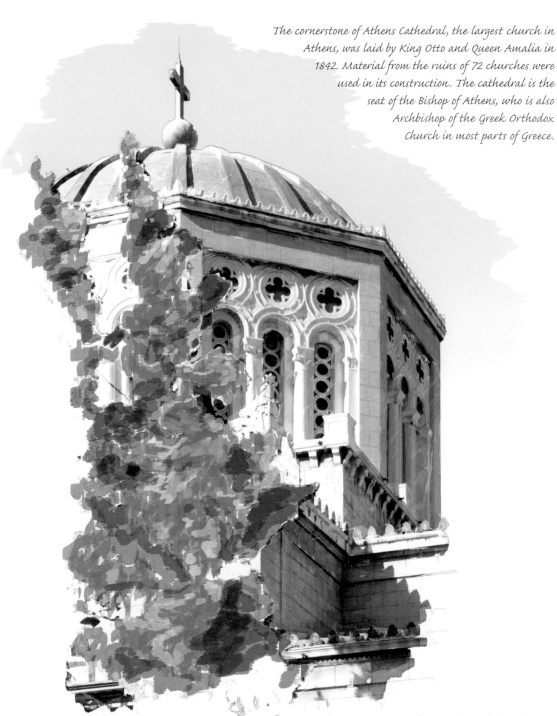

The cornerstone of Athens Cathedral, the largest church in Athens, was laid by King Otto and Queen Amalia in 1842. Material from the ruins of 72 churches were used in its construction. The cathedral is the seat of the Bishop of Athens, who is also Archbishop of the Greek Orthodox Church in most parts of Greece.

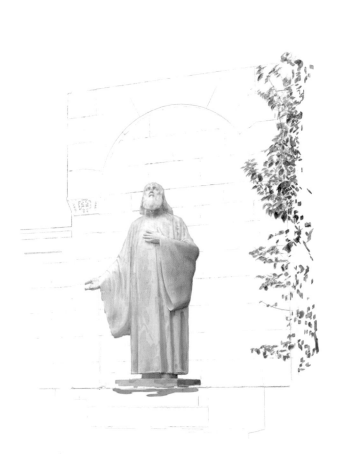

The statue of Gregory V, Patriarch of Constantinople, stands behind the Little Metropolis. His remains, which are interred in the cathedral, were brought back to Athens in 1871, 50 years after he was hanged by the Sultan for failing to prevent the Greek uprising in Constantinople.

The Maria Callas Centre on Adrianou Street is the headquarters of the Athenaeum Conservatory. The fine neoclassical building was originally the home of the Andreas Cambas family and the warehouse for their wine business. During World War II, it was the headquarters of the Italian army, and later, successively, a hostel for the homeless, a zip-fastener factory and a restaurant. It was restored in 1998 and named after the Greek diva. Today it houses a concert hall, offices and a library.

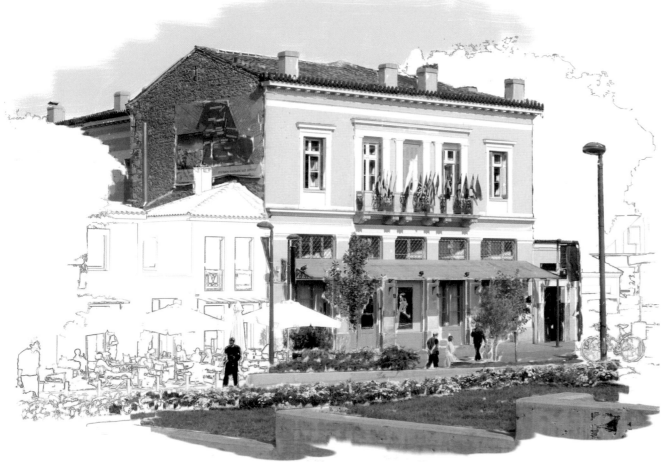

St. Philip's Church, opposite the Ancient Agora, was built in 1866 on the remains of a 17th-century basilica. It is believed that Saint Philip spoke to a gathering of Athenians on this site.

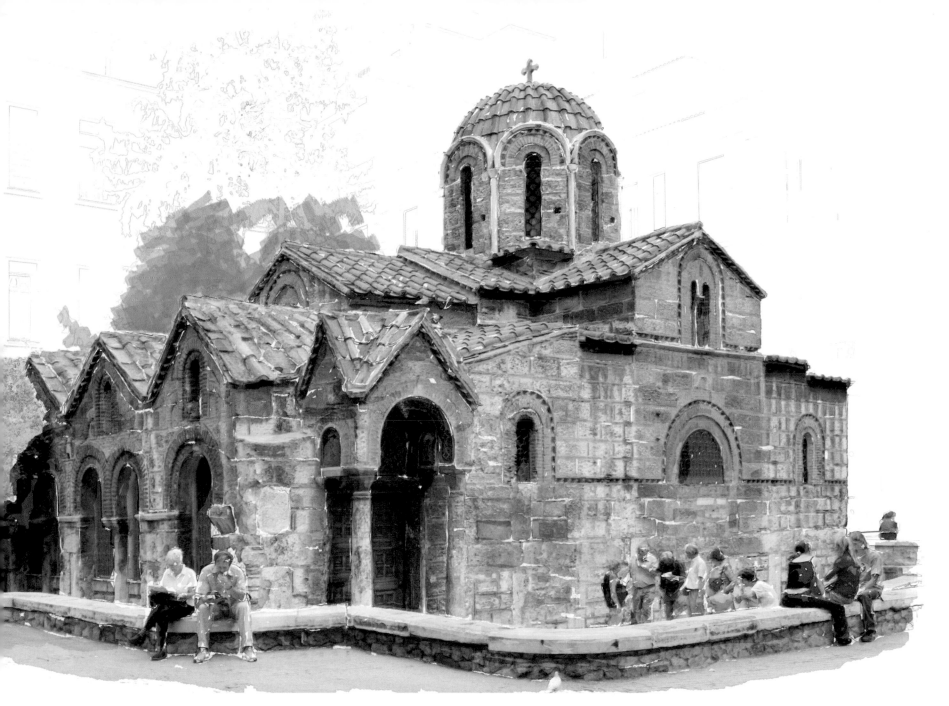

The charming Byzantine church of Kapnikarea, situated in a square in the centre of the modern shopping area of Ermou Street, dates from around 1060. It was slated for demolition after Independence but was saved through the intercession of King Ludwig of Bavaria. It was later restored by the University of Athens and is its official church.

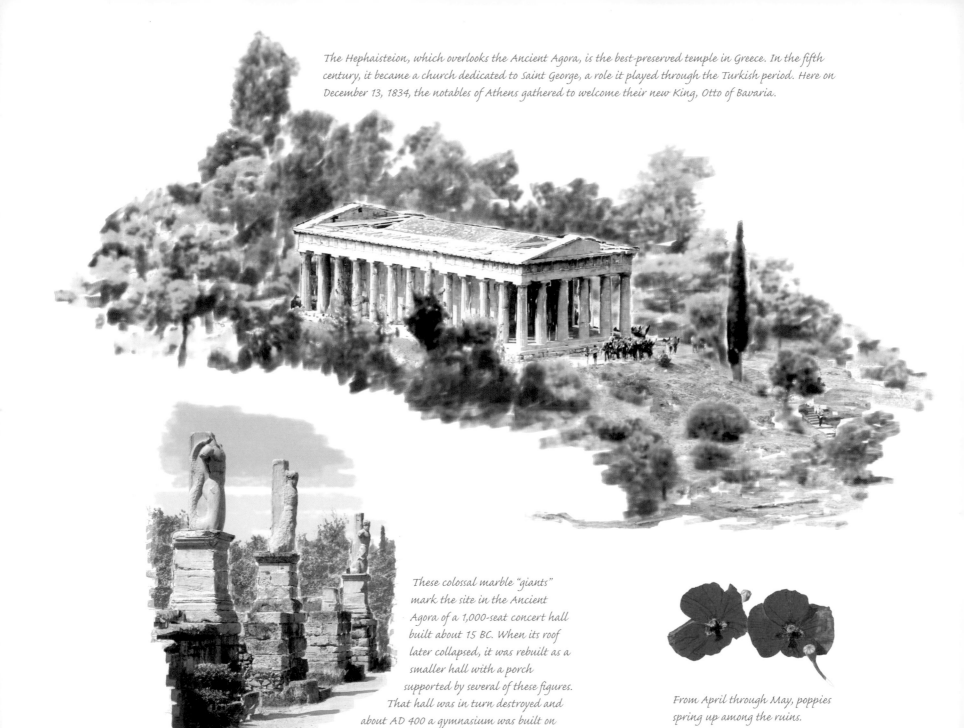

The Hephaisteion, which overlooks the Ancient Agora, is the best-preserved temple in Greece. In the fifth century, it became a church dedicated to Saint George, a role it played through the Turkish period. Here on December 13, 1834, the notables of Athens gathered to welcome their new King, Otto of Bavaria.

These colossal marble "giants" mark the site in the Ancient Agora of a 1,000-seat concert hall built about 15 BC. When its roof later collapsed, it was rebuilt as a smaller hall with a porch supported by several of these figures. That hall was in turn destroyed and about AD 400 a gymnasium was built on the site, with these four "giants" at the entrance.

From April through May, poppies spring up among the ruins.

The lightly-proportioned dome is
the oldest of what came to be
known as the Athenian type.
The fine paintings within are
probably mid-18th century.

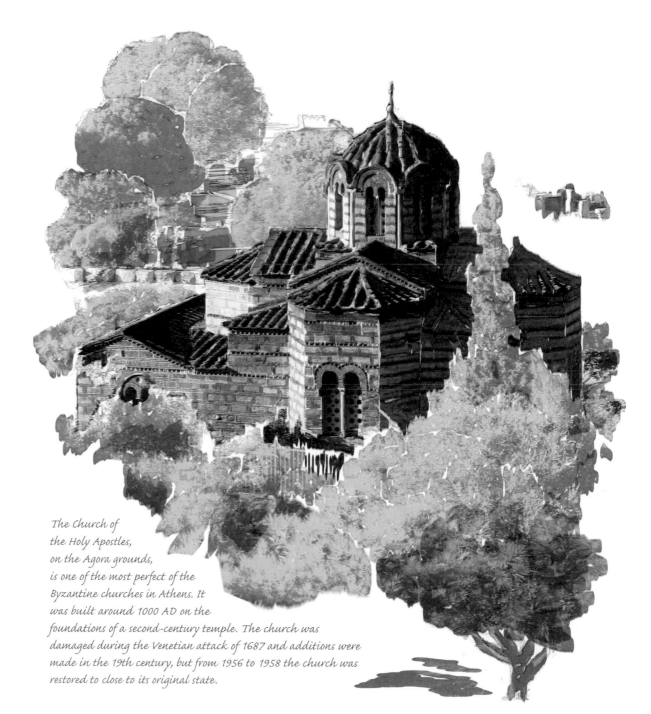

The Church of
the Holy Apostles,
on the Agora grounds,
is one of the most perfect of the
Byzantine churches in Athens. It
was built around 1000 AD on the
foundations of a second-century temple. The church was
damaged during the Venetian attack of 1687 and additions were
made in the 19th century, but from 1956 to 1958 the church was
restored to close to its original state.

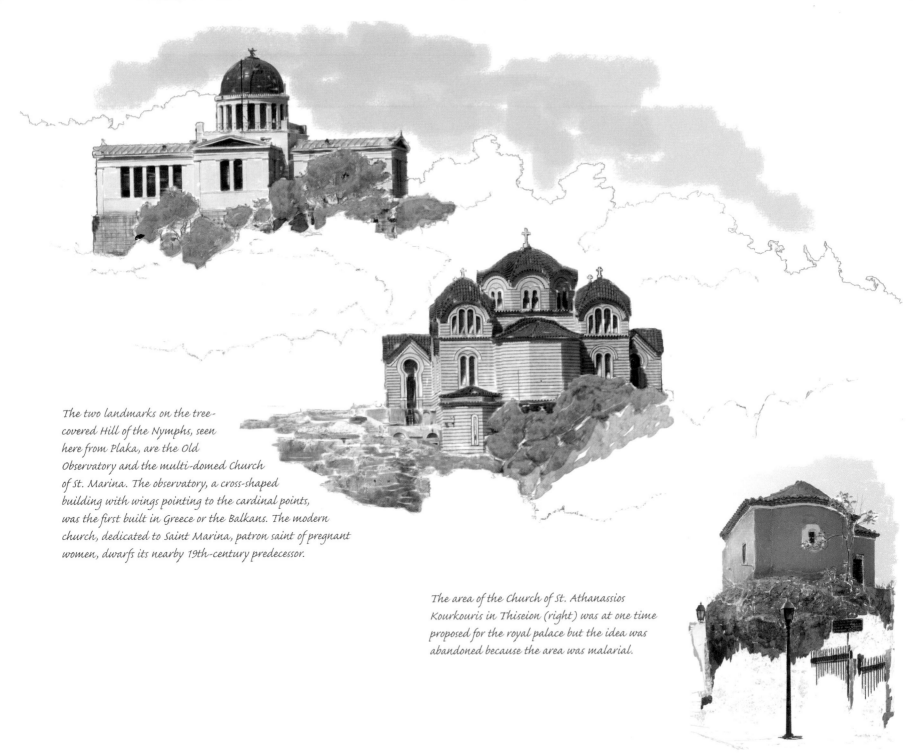

The two landmarks on the tree-covered Hill of the Nymphs, seen here from Plaka, are the Old Observatory and the multi-domed Church of St. Marina. The observatory, a cross-shaped building with wings pointing to the cardinal points, was the first built in Greece or the Balkans. The modern church, dedicated to Saint Marina, patron saint of pregnant women, dwarfs its nearby 19th-century predecessor.

The area of the Church of St. Athanassios Kourkouris in Thiseion (right) was at one time proposed for the royal palace but the idea was abandoned because the area was malarial.

Situated just outside the city walls, the burial ground at Kerameikos was active from the fifth to the third centuries BC. It was here in 432 BC that Pericles delivered his funeral oration to those who fell in the Peloponnesian War (see page 20).

The modern church of the Holy Trinity, designed by Ernst Ziller in 1915, is a conspicuous backdrop to the burial ground, excavated from under 10 m of overlay.

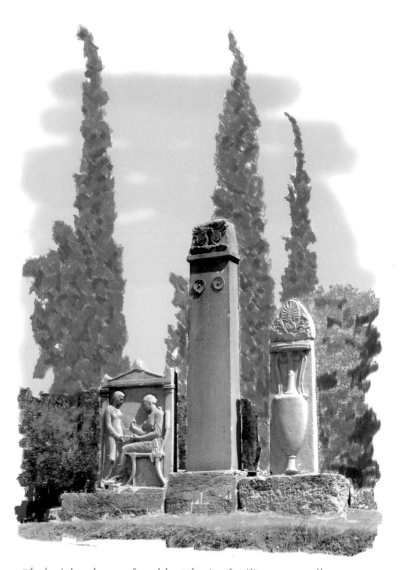

The Sacred Gate was an important exit in the wall of ancient Athens. The river Eridanos, which had its source at Mount Lycabettus and flowed through what is now Parliament Square and along the present Mitropoleos Street, exited the city in a paved channel through this arched opening in the gate.

The burial enclosures of wealthy Athenian families were usually marked with steles, reliefs and marble monuments. These grave markers on the plot of Eubios of Potomos, on the Street of Tombs, a branch of the Sacred Way, date from about 386 BC.

Lycabettus and the Neighbourhoods

Lycabettus Hill has been an Athenian landmark since antiquity. At an altitude of 277 m, it is higher than the 156-m Acropolis and offers a spectacular view of the sea. On top of the hill, the chapel of Aghios Georgios rises above the pine-clad upper slopes and the Greek flag waves from its bell-tower. At night, it is illuminated and looks like a castle.

Set in the heart of Athens, Lycabettus is an integral part of the city's life. You can get to the top of the hill by car, the funicular railway or on foot, to enjoy a meal at the restaurant or sip a coffee while gazing out over the city. In summer, the theatre on Lycabettus boasts a full house every night, packed with people attending concerts or plays.

Lycabettus rises like a cone from the dense apartments and office blocks of modern Athens. The neighbourhoods that have grown at its foothills, notably Kolonaki and Dexameni, are among the city's most wealthy with their steep streets clambering up its slopes. There are many embassies in the area, most of them housed in mansions with gardens. The Athenian Museum Mile stretches from Kolonaki to the Hilton, with the National Gallery, the Byzantine Museum, the Museum of Cycladic Art and the Benaki Museum all within walking distance.

On the other side of the hill from Kolonaki, Lycabettus is surrounded by built-up areas—Neapoli and the neighbourhoods above Alexandras Avenue. These are traditional middle-class Athenian areas where tall blocks of flats alternate with old houses. The view from Lycabettus is not only unforgettable, it is a good vantage point from which to take in the extent of the urban sprawl.

Athens's convenience stores. The ubiquitous kiosks, known as periptero, sell anything and everything and invariably have a public telephone on the counter.

Lycabettus Hill, a limestone rock reaching nearly 300 m into the blue Athenian sky, is a landmark which can be seen from all round the city. In the evening, the top half twinkles with lights. By day, it is a green-and-white hill topped by the glaringly-white Church of St. George.

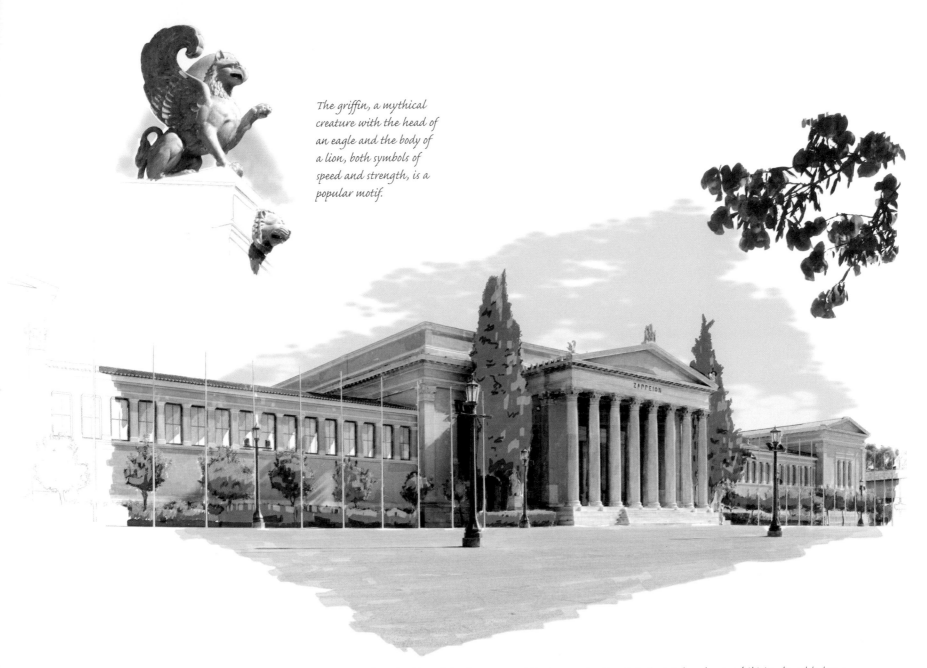

The griffin, a mythical creature with the head of an eagle and the body of a lion, both symbols of speed and strength, is a popular motif.

The imposing Zappeion Hall, set in expansive gardens, had its origins in a proposal that an agricultural, industrial and art exhibition be added to a revival of the ancient Olympic Games. The building, completed in 1888, was financed by Evangelos and Constantinos Zappas, the wealthy merchants after whom it is named. Zappeion was the venue for the fencing events of the first modern Olympics in 1896, and has hosted many historic conferences.

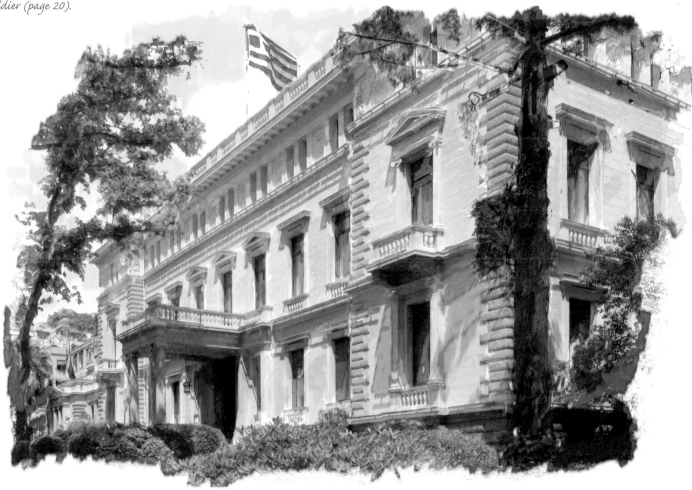

"Evzoni" of the Presidential Guard, created as a royal guard in 1914, mount honour guards at national ceremonies and guard the President's Mansion and the Monument to the Unknown Soldier (page 20).

The official residence of the President of the Hellenic Republic is also used for receptions and occasions, such as when diplomats present their credentials.

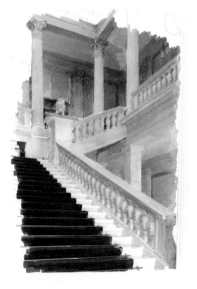

Now the official residence of the President of the Hellenic Republic, this mansion was commissioned when Crown Prince Constantine became engaged to Princess Sofia. It was completed in 1897. When the "Old Palace" burned in 1909, the royal family moved here and it became the "New Palace". The mansion stands in a garden of about 2.8 ha.

Costas Demetriadis's 1924 bronze "The Discus Thrower" stands opposite the entrance to the Panathenaic Stadium.

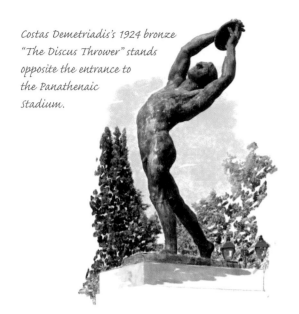

From March 31 till June 4, 2004, the Olympic flame was burning at the entrance to the Panathenaic Stadium, after which it began its journey round the world prior to the games.

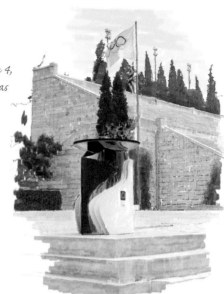

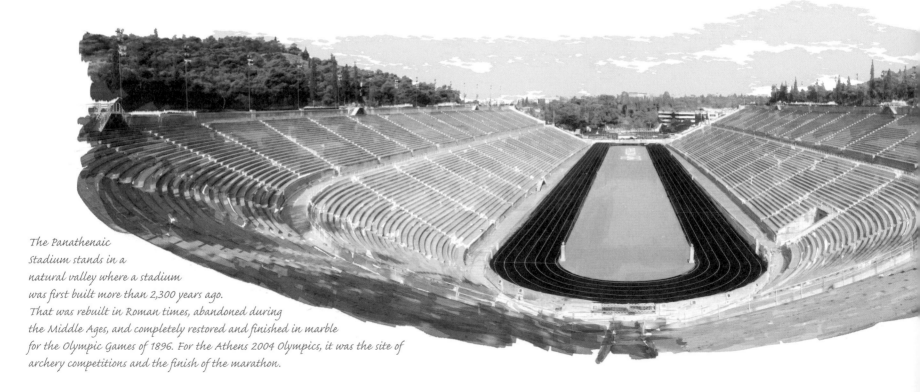

The Panathenaic Stadium stands in a natural valley where a stadium was first built more than 2,300 years ago. That was rebuilt in Roman times, abandoned during the Middle Ages, and completely restored and finished in marble for the Olympic Games of 1896. For the Athens 2004 Olympics, it was the site of archery competitions and the finish of the marathon.

The First Athenian Cemetery, founded in 1837, on the then outskirts of the city, is the final resting place for many of the central characters in the city's history.

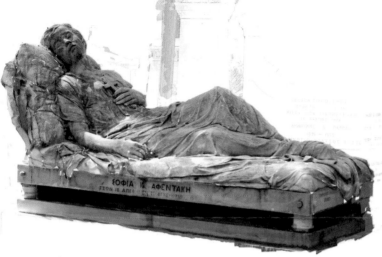

One of the best known among the many fine examples of 19th-century funerary art is "The Sleeping Girl", created in 1878 by sculptor Yiannoulis Chalepas from Tinos for the grave of Sofia Afendaki.

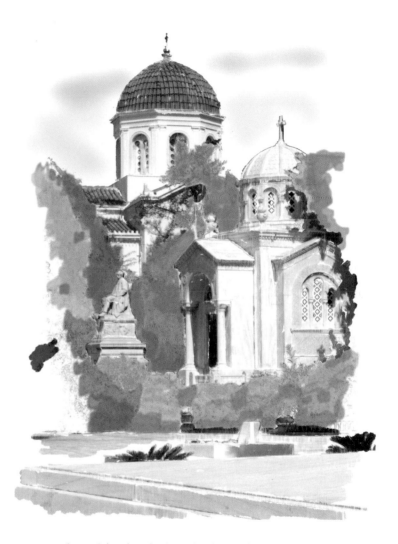

A crowd of 300,000 attended the funeral of actress, singer and politician Melina Mercouri (1922–1994). She is also commemorated in a bust opposite the Olympeion, the Cultural Centre named after her (page 78), and the Acropolis metro station dedicated to her memory (page 8).

In front of the Church of St. Theodore is the grave of Andreas Papandreou (1919–1996), economist, professor, president of the PASOK political party and twice Prime Minister.

Vasilissis Sofias Avenue, one of Athens's most elegant streets, is a living museum of the city's neoclassical and modern architecture.

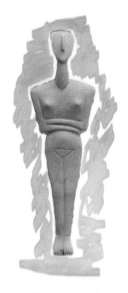

This abstract female figure in marble is representative of the Cycladic art that flourished in the Aegean Sea between 4,000 and 5,000 years ago.

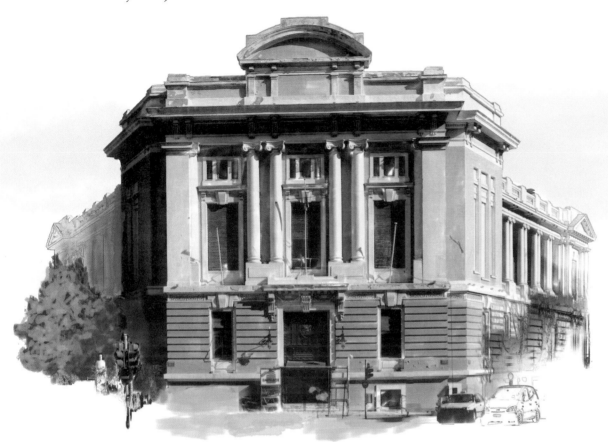

The Sarogleion is home to the Armed Forces Officers Club. Completed in 1934 to a design by architect Alexandros Nikoloudis, it is the main representative of Beaux-Arts architecture in Athens. It was finished with a bequest from Petros Saroglou, an artillery major, for whom it is named.

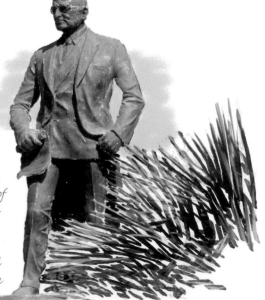

The Truman Statue was erected in 1963, a gift from Greek Americans in memory of the US President. He symbolically clutches a copy of the Truman Doctrine, his March 1947 declaration of immediate economic and military aid to Greece and Turkey to counter communist pressure on the two countries.

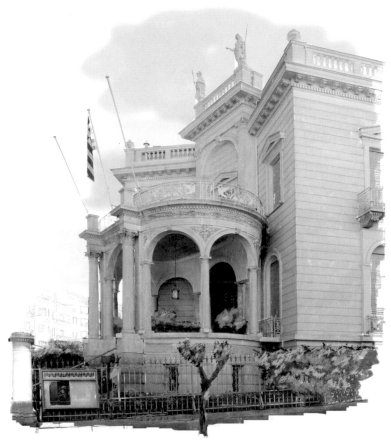

The Benaki Museum was founded here in 1930 in his family home by Antonis Benakis, based on his lifetime collection of antiquities, Byzantine art, and religious and secular art from the 15th to the 19th centuries. The collection includes many paintings, drawings and lithographs of Greece and, especially, early photographs of Athens.

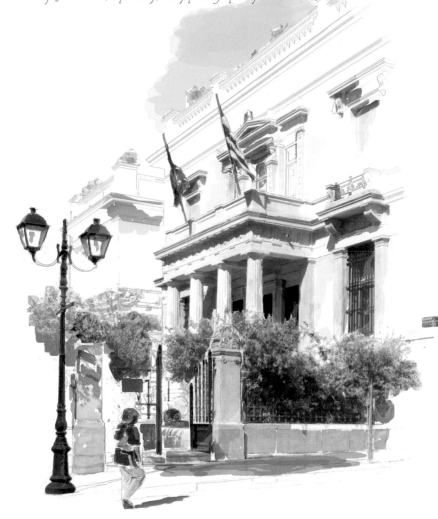

The magnificent Megaron Stathatos houses an extension of the Museum of Cycladic Art, founded in 1986 around the collection of Nicholas and Aikaterini Goulandris. It is dedicated in particular to the study and promotion of the art of the Cycladic culture.

This modern sculpture, erected in front of the Kolonaki International Centre on Vasilissis Sofias Avenue in 1993, is by Christina Sarandopolou.

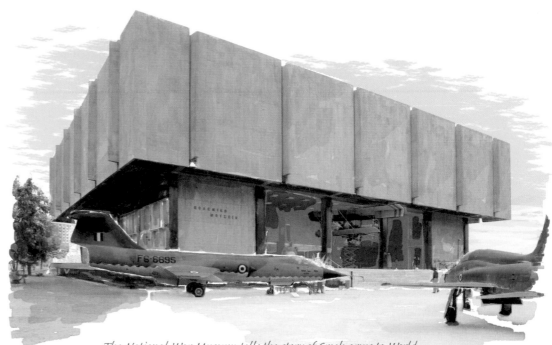

The National War Museum tells the story of Greek arms to World War II. A major attraction is the collection of warplanes in the forecourt, including two shown heare — the Lockheed F 104 G "Starfighter", a 1963 vintage fighter/bomber capable of Mach 2 speeds; and the Northrop F-5A supersonic "Freedom Fighter" (1964). The museum was opened in 1975.

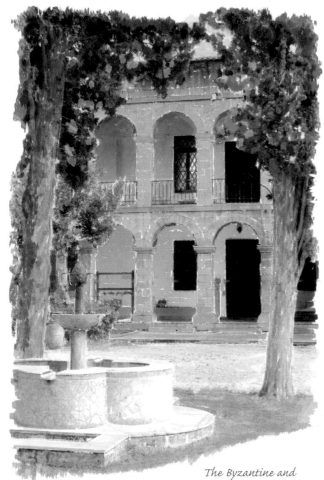

The Byzantine and Christian Museum is housed in the 1848 Villa Ilissia, formerly the townhouse of an enigmatic philhellene, Sophie de Marbois-Lebrun, Duchesse de Plaisance. The museum provides an excellent overview of Early Christian and Byzantine art and architecture. The fountain in the courtyard is a copy of one shown in a mosaic at the church at Dafni.

The National Gallery of Art, joined with the collection of lawyer and art-lover Alexandros Soutzos, showcases the work of Greek painters from the 19th and early 20th centuries. It now comprises some 9,500 paintings, sculptures and engravings. The modern building was opened in 1974. The bronze in the forecourt, "Dying Centaur" by Antoine Bourdelle (1861–1929) is part of a temporary exhibit from Paris.

The lovely Rodocanachi Residence is a fine example of residential architecture from the inter-war years. After World War II, the house was briefly an embassy, then a hotel from the 1950s, and a casino in 1989. In the late 1990s, it was beautifully renovated by the InterAmerican Group which now occupies it.

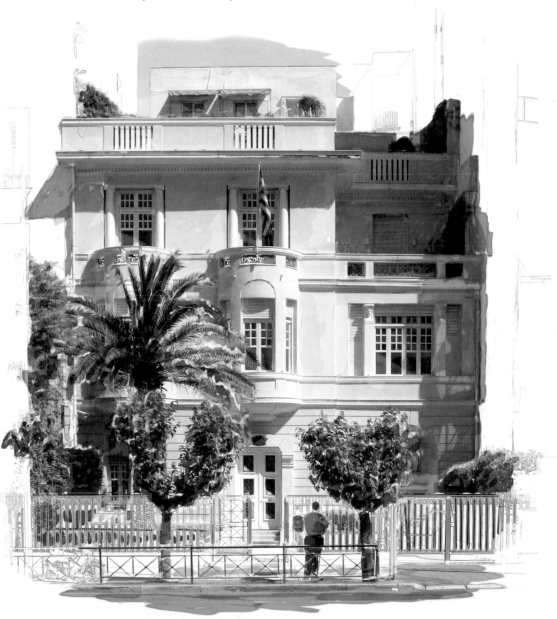

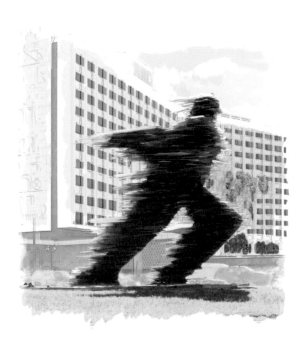

"The Runner", a sculpture made of horizontal glass sheets by Athenian Kostas Varotsos, stands before the Hilton Hotel. Formerly in Omonia Square, the statue was moved to the present site in 1994 when the square was excavated for metro construction.

The Gennadeion Library houses the world's best collection of rare books from or on Greece. It was founded on the lifetime collection of Ioannis Gennadius, for many years in the Greek diplomatic service in London. The reading room is shown here.

Gennadius donated his collection to the American School of Classical Studies. The Carnegie Corporation agreed to fund premises and architect Stuart Thomson's wonderful classical-style building, opened in 1926, was the result. On the building's facade is inscribed, "They are called Greeks who share our culture", a statement of the ancient Greek orator Isocrates.

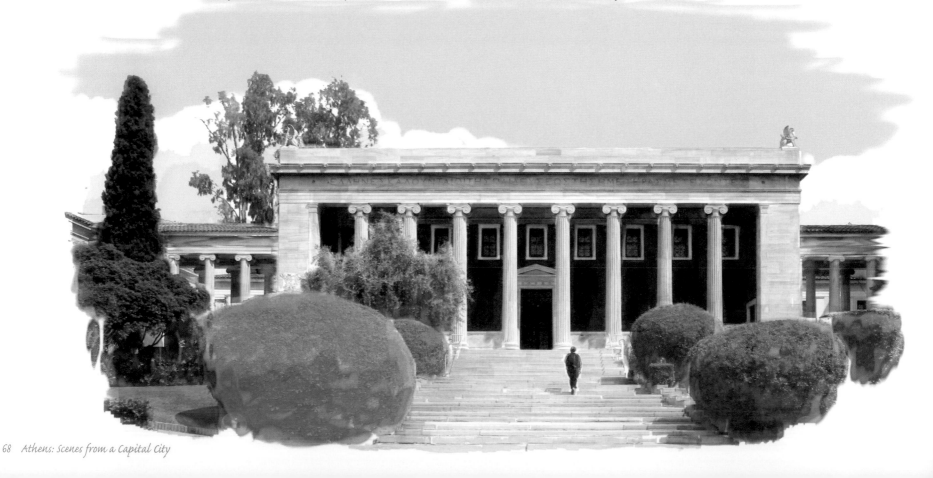

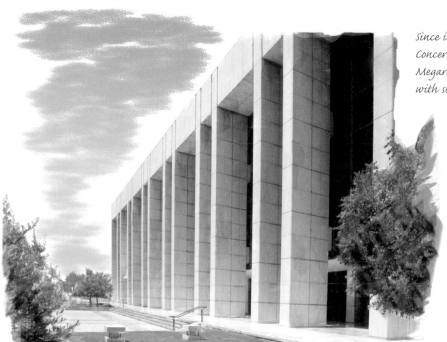

Since it opened its doors to the public in 1991, the superb acoustics of the Athens Concert Hall have been acclaimed by both the public and performers. The Megaron Mousikis, or simply "The Megaron", has two concert halls, the larger with seating for 2,000. An extension of twice its size opened in 2005.

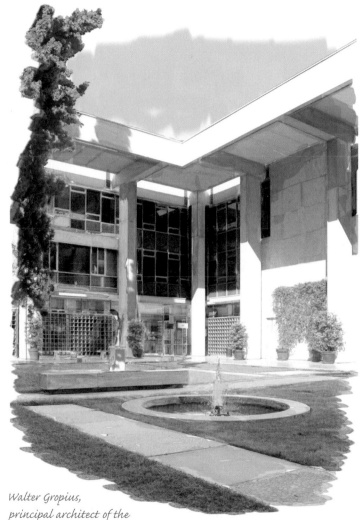

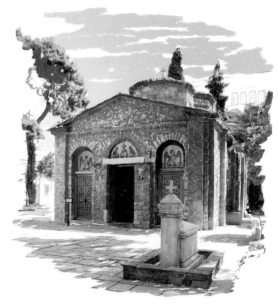

In Lycabbetus, a 14th-century church consecrated to the Archangels stands in the grounds of Moni Petraki, a monastic compound founded in 1673. During the Ottoman period, the monks gave medical care to the locals and after Independence, the monastery was used as a hospital. The tomb in the foreground is that of a Greek scholar of the Ottoman period, Konstantinos Ekonomou (1780–1857).

Walter Gropius, principal architect of the United States Embassy building, opened in 1961, founded the influential Bauhaus school of design. Its emphasis on functional, simple architectural styles is reflected in this building's fine balance between the classical and the modern. The view is of an inner courtyard.

Kolonaki Square is overlooked by this graceful 1920s block on the corner of Skoufa Street. With a discreet curved projection extending to both residential floors, it features the early Art Deco style of the period.

Plane trees provide a welcome shade in Athens's summer heat.

Bustling with coffee shops and boutique stores, Kolonaki Square is the centre of an upmarket quarter of Athens that started to develop only at the end of King Otto's reign.

This four-storey house, built on Lykavittou Square in 1925, is one of the largest and most impressive private mansions in the centre of Athens. A happy adaptation of late Classicism, it is the work of architect Ioannis Alexos.

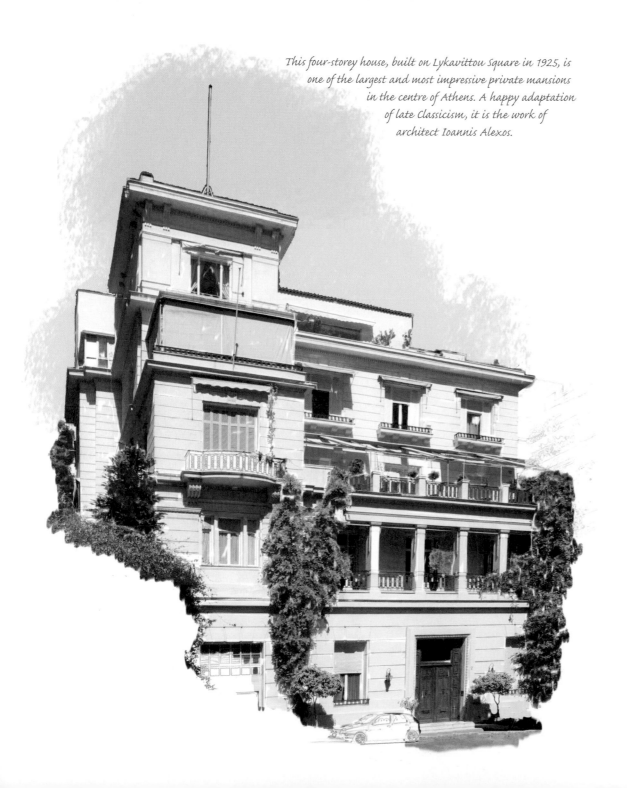

The Church of St. Dionysius on Skoufa Street is dedicated to the first bishop of Athens, its patron saint. It was designed by Anastasios Orlandos, an archaeologist, architect and member of the Academy, and built between 1923 and 1931. The mosaics on the impressive porch were added in 1972 and 1973 by Sotirios Varvoglis.

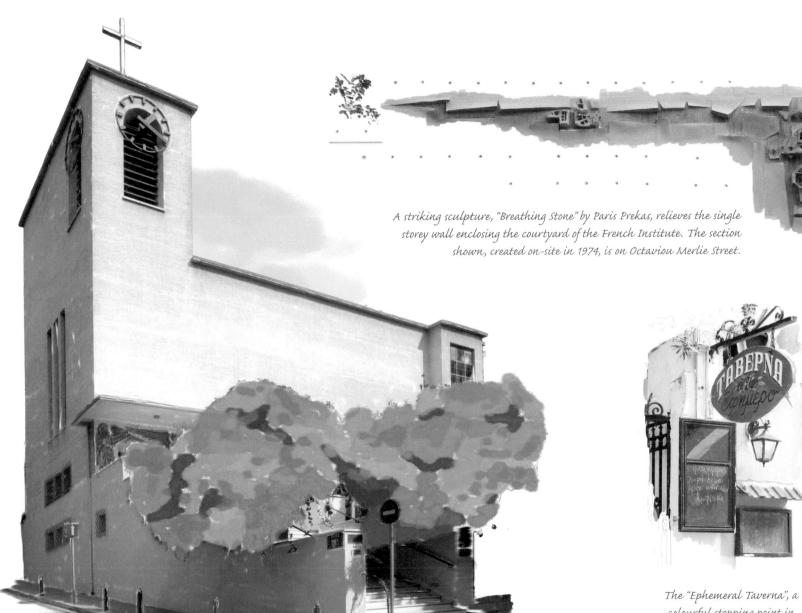

A striking sculpture, "Breathing Stone" by Paris Prekas, relieves the single storey wall enclosing the courtyard of the French Institute. The section shown, created on-site in 1974, is on Octaviou Merlie Street.

The "Ephemeral Taverna", a colourful stopping point in Exarchia, Athens's Latin Quarter. On the menu for the day — pork with celery and lamb with red sauce.

The German Evangelical Church in Athens was founded within the Royal Palace in the time of Queen Amalia. After the death of King George I in 1913, the congregation was granted land by the Greek state to build its own place of worship, and in 1934 moved to its permanent home, Christ Church on Sina Street.

This graceful double doorway at 46 Sina Street fronts one of the few purely art nouveau houses in Athens. It combines Byzantine and Western elements, a reflection of its architect's origins in Smyrna. It was built around 1928.

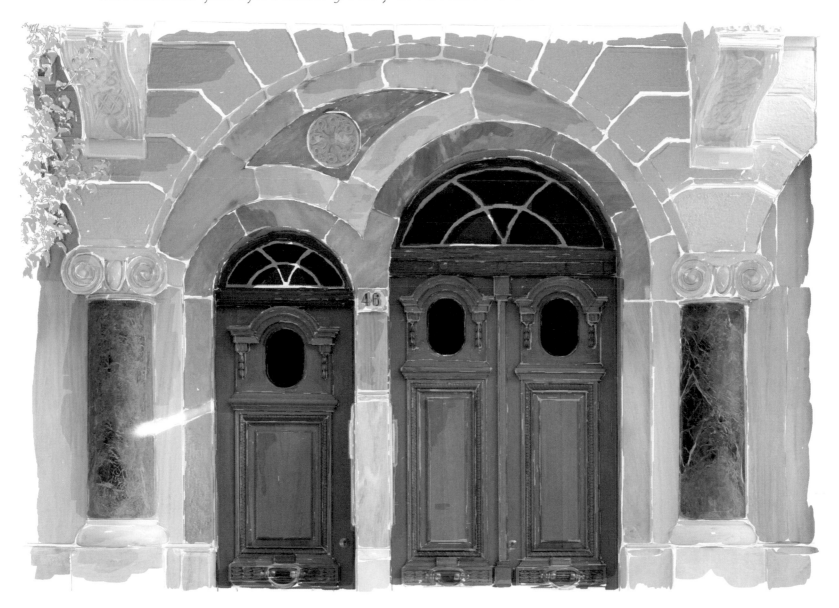

Evripidou Street in Psyrri, one of the oldest neighbourhoods in Athens, once on the outskirts of Ottoman Athens, is lined with a medley of small wholesale and import businesses.

The Church of St. Irene, on Aiolou Street, was built on the site of an earlier church dedicated to the same saint. The facade blends neoclassical arches and pediments with the Byzantine style narthex, shown here. After the creation of the Greek State, the earlier church served as the Cathedral, and the first Independence Day celebrations were held there on March 25, 1838. However, the building was clearly not impressive; the heroic General Yannis Makriyiannis referred to it as "a hut". It was demolished and the construction of the new church started in 1846. It opened in 1850.

The Central Market, also known as the Varvakeios or Municipal Market, was built on Athinas Street between 1876 and 1886. It was fortuitous timing, as the Upper Bazaar, which operated for many years within the ruins of Hadrian's Library, was destroyed by fire in 1884. The design by the architect Ioannis Koumelis reflects many European markets of that period. A major renovation was completed in 2005.

The building houses the fish market, while the meat market is in three surrounding arcades. Low prices, variety and fresh produce entice buyers from all over Athens.

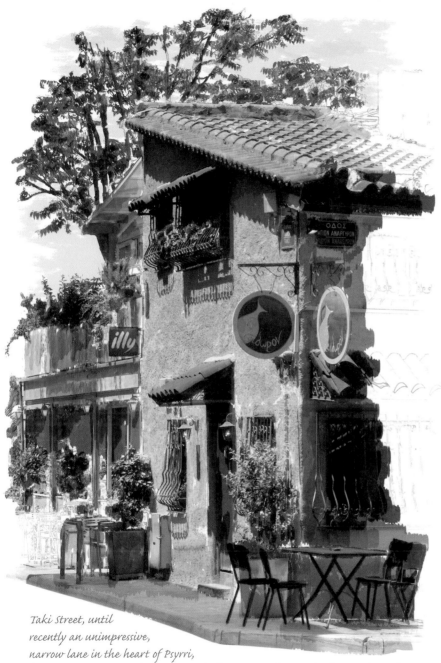

Taki Street, until
recently an unimpressive,
narrow lane in the heart of Psyrri,
has undergone a transformation with the opening of new wine bars and trendy
dining places like the Restaurant Zeidoron, shown here.

One of the murals decorating "Y
Taverna tu Psiri", described as
"the last work-a-day taverna"
and located on Aeschylou Street
in Psyrri, raises a smile from
passers-by at the unlikely
scholars lining up to enrol at
an equally unlikely "school".

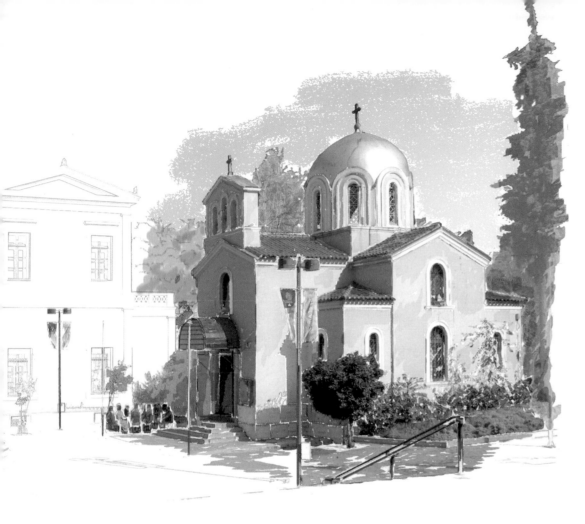

Koumoundourou Square is named after a former Prime Minister whose house stood here. At the west end of the spacious and recently renovated square are the Church of the Penniless Saints and the Municipal Art Gallery. The gallery specialises in 19th- and 20th-century Greek artists and has a collection of some 2,500 works. Its neoclassical building was originally opened in 1874 as a Public Foundling Hospital, sponsored by Queen Olga.

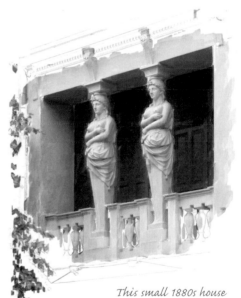

This small 1880s house at 45 Agion Asomaton Street is famous for its twin caryatids which, tradition claims, commemorate the early deaths of two beautiful girls of the neighbourhood. For decades it had a barber's shop on the ground floor. It was immortalised in the photography of Henri Cartier-Bresson.

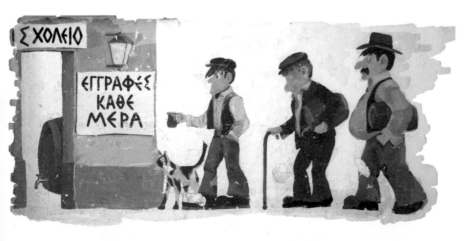

The Cultural Centre, named after the actress and later Minister of Culture, Melina Mercouri, is housed in a former hat factory. The plant's distinctive architecture, with its ceramic tiles spelling out the name, "Elias Poulopoulos and Son, The Greek Hatmaker", and the fanciful mural that includes one of its erstwhile products, have been preserved. On the upper floor of the museum is a "Travelogue of Athens", an exhibit portraying neighbourhood shops of a century ago with their wares and paraphernalia including a barber's, a coffee shop, a chemist's and a printer's.

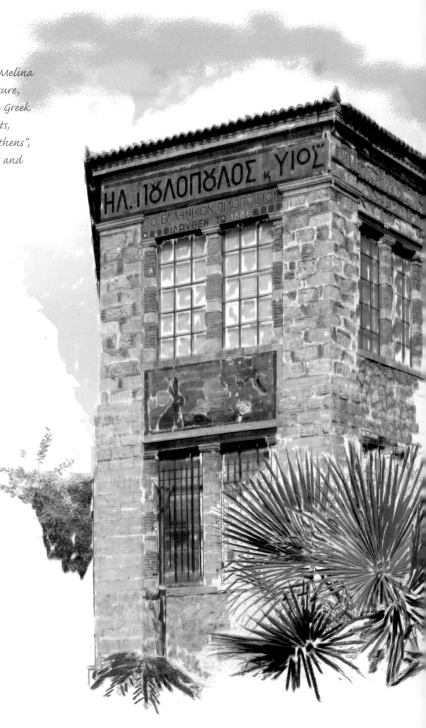

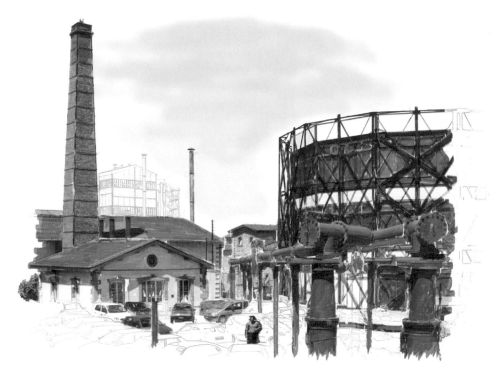

The Technopolis in Gazi is a cultural centre offering festivals and exhibitions of art and technology. It was created from a plant which formerly produced gas for lighting and power throughout the city. The centre, dedicated to composer Manos Hatzidakis, has spawned a revival in a previously run-down quarter of Kerameikos.

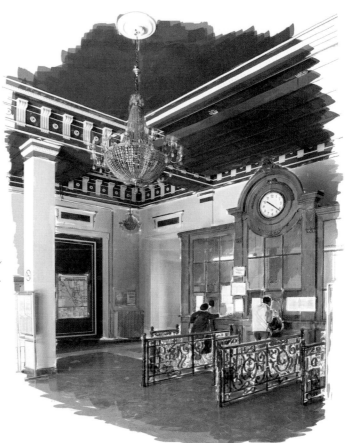

Peloponnissou railway station on the Piraeus-Athens-Peloponnese line is one of Athens's designated historical monuments. It was built in 1889 but remodelled in its present form in 1912 and 1913 after the Gare des Chemin de fer Orientaux in Constantinople, but with a less flamboyant style and with art nouveau elements added. The colourfully-restored booking office, shown here, is a delightful reminder of a bygone age.

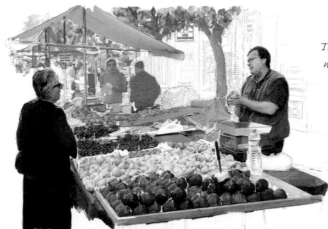

The market on Chiou Street, near Karaiskaki Square in the Agios Pavlos (Saint Paul) District, is an example of the popular weekly open-air bazaars that rotate round residential areas of the city.

The Athens Polytechnic was founded in 1836 as the Royal School of the Arts, initially focussed on training builders for the army. The school became a centre for higher education with a broader curriculum in the years after 1873 when it moved to this fine neoclassical building on Patission Street. It is now Athens's principal institution for university-level training of engineers and architects.

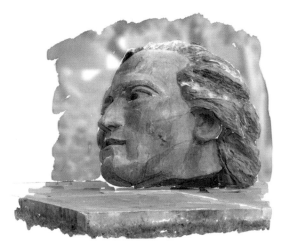

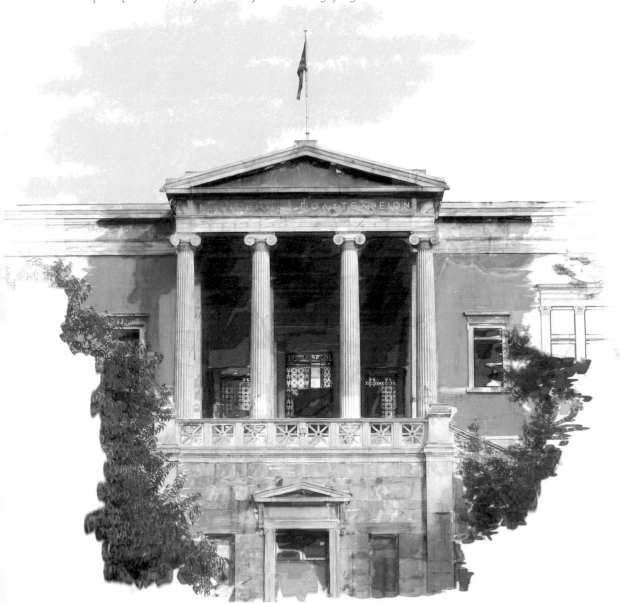

In November 1973, a student occupation of the polytechnic protesting the military regime was brutally put down by the army, and some 20 students were killed. The event led to the fall of the junta the following year. The dead students are memorialised by Memos Makris's sculpture, "Head in Honour of the Dead", that is set in the grounds of the polytechnic.

This bronze of Emperor Augustus (29 BC–AD 14), exhibited in the National Archaeological Museum, was found in the Aegean Sea near the island of Euboea (modern Evia). It depicts the emperor mounted on a horse and raising his hand in greeting, and dates from about 10 BC. Augustus was one of a string of Roman emperors who embraced Greek culture and embellished Athens during their reign.

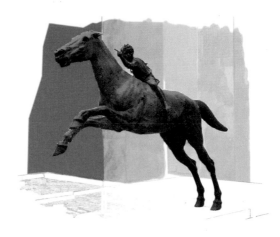

One of the many excellent bronzes in the museum's collection is this young man on a horse that dates from about 550 BC. It was found at Dodone, the most important ancient site in Epirus.

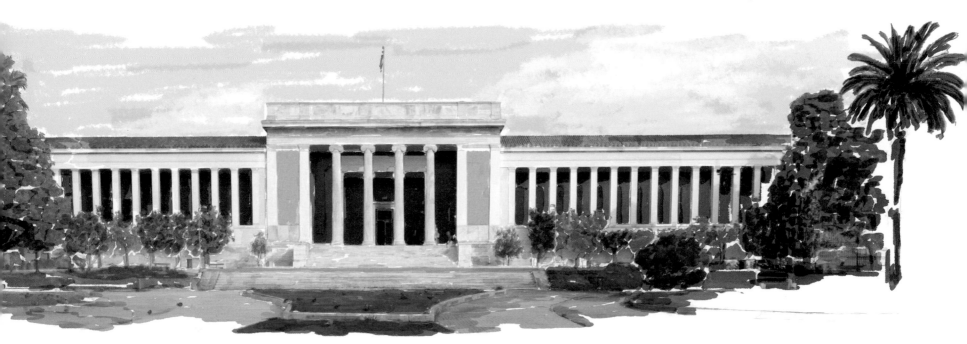

The National Archaelogical Museum first opened in 1889 and brought together an incomparable collection of sculptures, bronzes and ceramics from all over Greece, from prehistory to the late Roman period. Following damage by an earthquake in 1999, the museum was renovated and the collections rearranged. It was reopened in 2004.

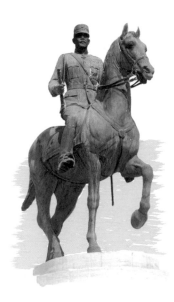

The former Officer Cadet School (Skoli Evelpidon) in the Field of Mars (Pedion tou Areos), a 20-ha park founded in 1934 and dedicated to the heroes of the War of Independence, was designed by architect Ernst Ziller, paid for by Georgios Averoff, and built between 1889 and 1894. The stately neoclassical building now serves as law courts.

The bronze statue of King Constantine I in Areos Park was cast in Italy by the architect Constantino Vetriani and sculptor Francesco Parisi. It was erected in 1938.

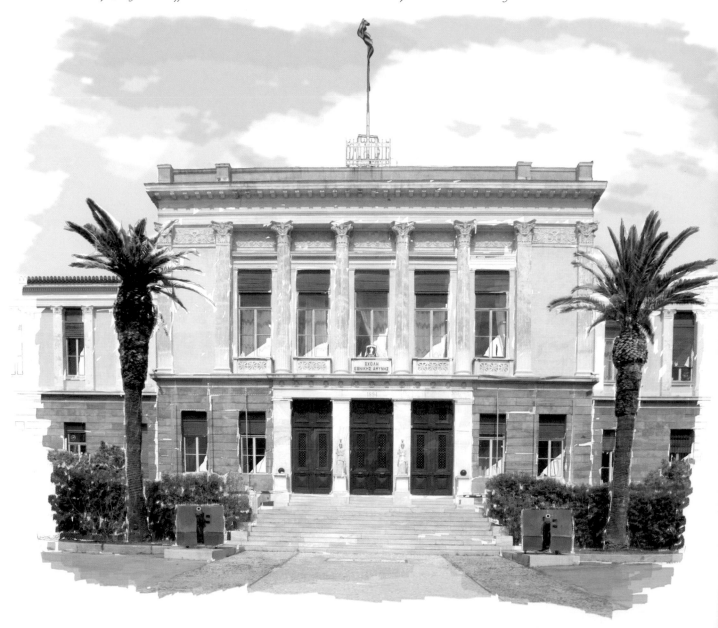

The Supreme Court Building, seen here from across busy Alexandras Avenue, was completed in 1980. An appropriately awesome facade dominates the Law Courts complex which includes the Court of Appeal, the Court of First Instance and Magistrates' and Police Courts.

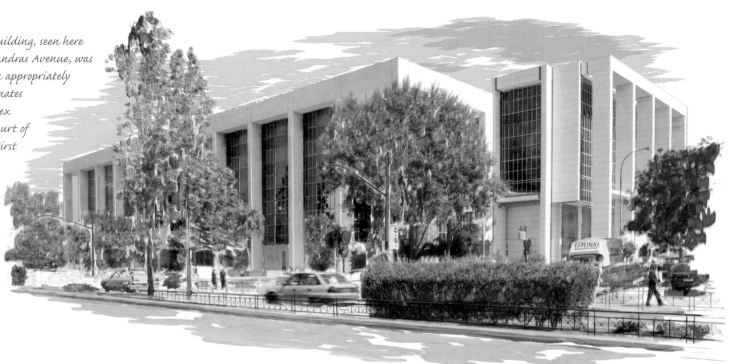

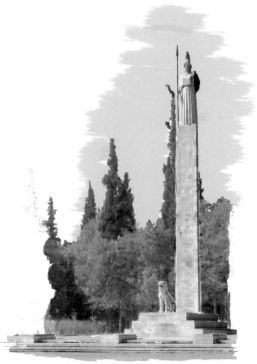

A memorial installed in Areos Park in 1952 commemorates soldiers of the UK, Australia and New Zealand who died "for the liberty of Greece" in World War II. The arms of the three countries are displayed on cenotaphs guarded by a seated lion. A statue of Athena with spear and shield stands on the tall stele behind.

This stately mansion at 26 Alexandras Avenue was designed by Ernst Ziller in 1908 for the Athens branch of the Austrian Archeological Institute, still located here and built on land donated by the Greek State. From 1947 to 2003 it also housed the Austrian Embassy.

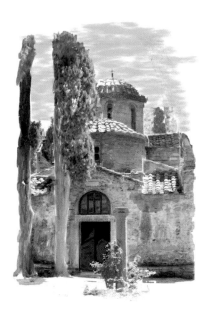

The domed cross-in-square church of the well preserved Kaisariani Monastery on the slopes of Mount Hymettus dates from the 11th century.

From Mountain to Sea – Outer Athens

In order to comprehend the richness of contemporary life in Athens one must venture beyond the boundaries of the historic centre. A large proportion of the population of Athens lives in suburbs that keep spreading out in all directions. These suburbs are inter-dependent satellites of all types, ranging from populous working class neighbourhoods to affluent garden cities. For the 2004 Olympic Games, Athens mainly made use of the outlying zones of the city. The famous Olympic Stadium, designed by Santiago Calatrava, is in Maroussi, north of Athens.

The Greek capital also offers its dwellers holiday escape routes both to the sea and the mountains. The renowned beaches of Attica extend along the Saronic Gulf and eastwards towards the airport on the southern Euboean Gulf and towards the Aegean. In the northern suburbs, the old villas of garden cities lie alongside the large multiplex cinemas and shopping centres that have spread to every part of Attica.

The climate is generally cooler in the north, apparent also in the kind of vegetation found there. In the southern suburbs with their carefree atmosphere, their beaches are full of people by the end of May. From Sounion with its classical temple to the port of Piraeus, the coastline changes constantly. Piraeus, now incorporated into the urban complex of Athens, is a busy port where industry once thrived—it was known as the "Manchester of the East". In 1923, it received thousands of Greek refugees, following the exchange of populations with Turkey. Today it is a leading mercantile and shipping centre that links Athens with the Aegean Islands and Crete.

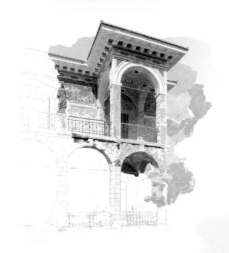

The unique Villa Kazouli on Kifissias Avenue was built in 1910 for Nicholas Kazouli, a businessman from Egypt. The landmark cupola with its lotus finial was the creation of his architect son-in-law Panayotis Aristophron. During World War II, the villa was requisitioned by the German army and suffered considerable damage. After years of neglect, it was restored in 1995 and today houses Greece's National Centre for the Environment and Sustainable Development.

The Villa Atlantis is a fine example of several residences in Kifissia designed by Ernst Ziller. It was built in 1897 for Solon J. Vlasto, founder of the Greek-language newspaper Atlantis, published in New York from 1894–1973.

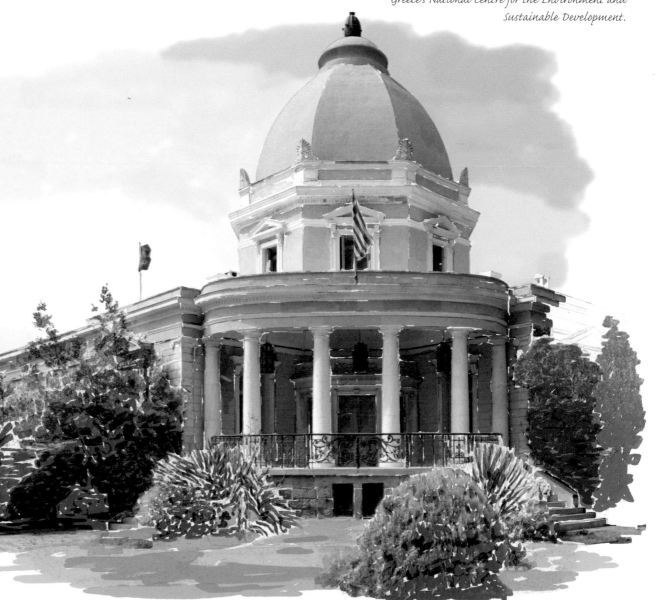

The flame, which burned brightly at the end of the Olympic stadium throughout the Athens 2004 Games was, like the torch by designer Andreas Varotsos from which it was lit, inspired by a curled olive leaf.

The Olympic Stadium at Maroussi was built in 1982 and the landmark roof, designed by Santiago Calatrava, one of Europe's foremost architects, was added for the Athens 2004 Olympics. The tubular steel arches supporting the roof span over 300 m, and rise to over 70 m. The stadium seats 72,000 and was the venue for the spectacular opening and closing ceremonies and for athletics events and the soccer final. It is but one part of the complex developed for the highly successful games.

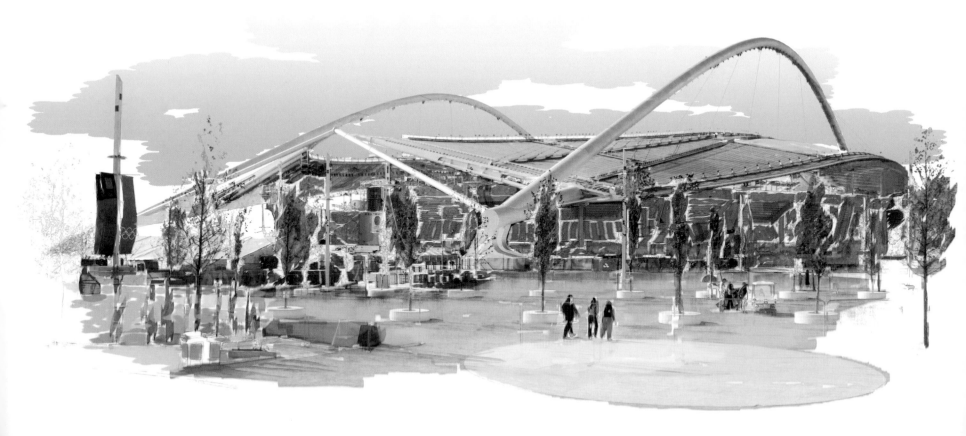

One of the exhibits in the
Railway Museum in Sepolia,
a northern suburb of Athens,
is this coal-burning steam
locomotive from the Diakofto
to Kalavryta "Tooth" railway.
The locomotive was built in
Paris in 1899.

Santiago Calatrava's iconic "Harp" Bridge at Katechaki provides a pedestrian crossing of
busy Mesogeion Avenue from the metro station. It was opened in 2003. Calatrava
trained as both engineer and architect, and his unique swooping shapes,
which often seem poised for flight, reflect an aesthetic sensibility
informed by his engineering skill.

At Galatsi in northern Athens is
one of the few standing sections of
the 20-km long aqueduct started
by Hadrian, Roman emperor from
117–138 AD, to carry water from
Mount Parnes to a reservoir
(Dexameni) on Lycabettus, which
then supplied Athens.

This bust of Queen Olga, wife of King George I, stands in front of the Evangelismos Hospital that she founded in 1883.

The campanile of Nea Smyrni's Cathedral replicates the bell tower of St. John the Theologian in Smyrna, destroyed in 1922. Nea Smyrni, a southern suburb of Athens, was created to settle some of the 1.2 million refugees who poured into Greece during the exchange of populations following the 1921 sack of Smyrna. In this highly-successful community, its history is ever to the fore.

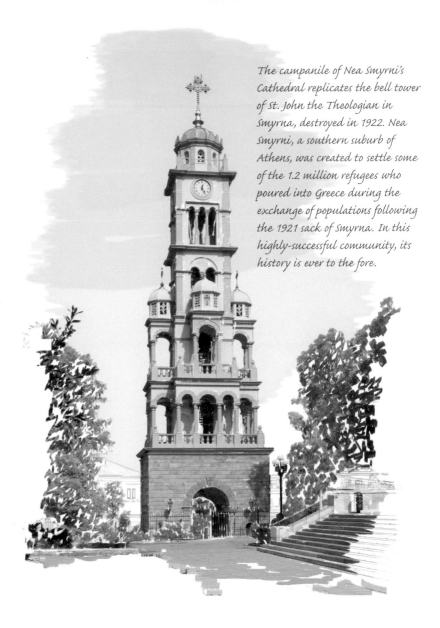

The Church of St. Sostis stands on the site of the 1898 attempted assassination of King George I, beside what is now Syngrou Avenue, south-west of the city centre. It was erected in thanksgiving for the "miraculous" escape of the King. His queen, Olga, led the fund raising. The King was later to be assassinated in Thessaloniki.

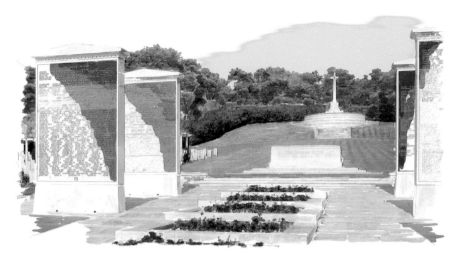

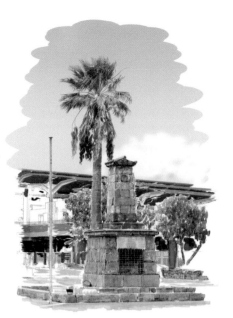

A monument marks where George Karaiskakis, one of the ablest leaders in the War of Independence, was fatally wounded in 1827. Behind are the gull-winged canopies of Neo Faliro's metro station.

Perhaps the best-tended lawns in Athens are those of the serene Commonwealth War Cemetery in Faliron. The large monuments in the foreground bear the names of the soldiers of the British Commonwealth and Empire who died in the Greek theatre of operations but "to whom the fortune of war denied a known and honoured grave".

The "Georgios Averoff" is the world's only surviving heavy cruiser of the early 20th century. Commissioned in 1911, the Italian-built warship had a distinguished service career as the Greek flagship before being opened as a museum at the Marina Trokadero in Faliron Bay.

Piraeus has been the port of Athens since ancient times. It was revitalised, with neoclassical buildings and modern factories, after Athens became the Greek capital in 1834, and today is a modern, cosmopolitan, port city.

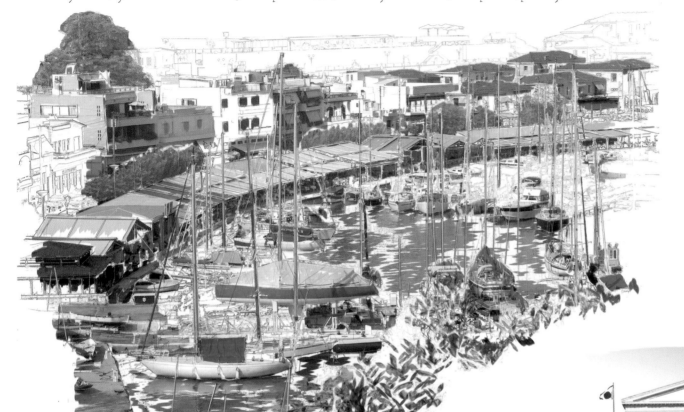

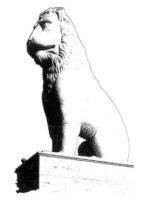

A white marble lion that stood guard over Piraeus's harbour for 2,000 years, and gave rise to its alternative name of Porto Leone, was carried off to Venice in 1687. This poor modern version overlooks the port from close to the original site.

The picturesque Mikrolimano or "little harbour" in Piraeus is the site of the ancient port of Munychia. The yacht basin, seen here from the Yacht Club of Greece, is popular for its waterside fish restaurants, and its relaxing ambience attracts visitors from all parts of Athens.

The symmetrical neoclassical facade of the imposing Municipal Theatre is one of the jewels of Piraeus. Opened in 1895, the 1,300-seat theatre hosts a variety of cultural events and is the home of both a Museum of Stage Décor and the Municipal Art Gallery, inaugurated in 1957. A special place is reserved for the works of Piraeus artists among its paintings and sculptures.

Construction of the original Holy Trinity, the magnificent cathedral of Piraeus which is a landmark for sailors entering the harbour, was finished in the early 1840s. It was completely destroyed by Allied bombing in 1944 but rebuilt by architect Georgios Nomikos from 1956 to 1964, closely following the original.

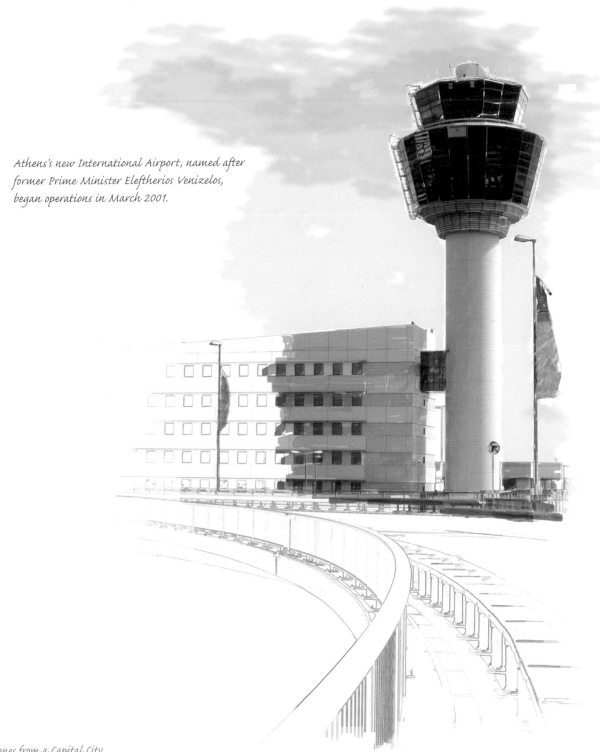

Athens's new International Airport, named after former Prime Minister Eleftherios Venizelos, began operations in March 2001.

The striking logo of the airport incorporates the Greek letter "A" against an Aegean blue background.

Gazetteer

SCENES from a CAPITAL CITY

Page 9
Lalaounis Jewellery Museum (c. 1923)
4 Karyatidon Street, Acropolis
The beautiful former home of Ioannis Lalaounis was designed by Professor Tsisouras and renovated by Vassilis Gregoriadis to plans by Bernard Zehrfuss. It was opened as a museum in 1994 and has on display 4,000 pieces created by Ilias Lalaounis from 1940–2000. The jewellery is inspired especially by the art of the Prehistoric, Bronze, Classical and Hellenistic periods and Byzantium.

Pages 9 and 27
The Academy of Sciences (1859–1887)
28 Panepistimiou Street
This fine neoclassical building, faced in Pentelic marble, was designed by Danish architect Theophilus Hansen and built with a donation from Baron Simon Sinas who is commemorated by a statue in the entrance hall. The design has been variously described as modelled on the Erechtheion and influenced by the parliament building in Vienna, where Sinas was Greek ambassador. Construction was supervised by Ernst Ziller who added his own ideas in the process. The pediments are filled with figures by Leonidas Drossis who was also responsible for the fine statuary on the forecourt. The portico frescoes by Eduardo Lebiedzky were painted after 1888.

The HEART of MODERN ATHENS

Pages 19 and 20
Parliament Building (1836–1842. Reconstructed 1930–35)
Syntagma Square
The former Royal Palace, designed by Bavarian architect Friedrich von Gärtner, reintroduced the Classical style in the city's architecture. Over large for its purpose, it boasted 365 rooms. King Otto and Queen Amalia moved in in 1843. After a fire which destroyed the interior in 1909, the royal family—at that time King George I and Queen Olga (see page 88)—moved to their summer palace at Tatoi and later to what is now the President's Mansion (page 61). In 1930, reconstruction began under architect Andreas Kiriazis to prepare the building to house Parliament.

Page 20
Monument to the Unknown Soldier (1932)
Parliament Square
The Monument to the Unknown Soldier was designed by architect Emmanuel Lazaridis and unveiled on Independence Day, March 25, 1932. The main element is a bas-relief of a dying "hoplite", a Greek soldier of the classical period, by Costas Demetriadis.

Ministry of Foreign Affairs (1872–73, 1930–40, 1973–78)
5 Vasilissis Sofias Avenue
The Andreas Syngrou Mansion was designed by Ernst Ziller and built between 1872 and 1873. It was bequeathed in 1921 by Syngrou's widow to the state on condition it became the permanent home of the Ministry of Foreign Affairs. The original design was changed during Syngrou's residence and radically altered between 1930 and 1940 after it passed to the Ministry. In 1985, the mansion was connected to a new building designed by Ioannis Vikelas, built from 1973–78. The whole building was listed in 1976.

Page 21
Hotel Grande Bretagne (1842–43, 1958, 2001–03)
Syntagma Square
The original neoclassical mansion was built from 1842–43 by Theophilus Hansen, who was later to design the National Library and the Academy (pages 9, 26 and 27), for Antonios Dimitriou. From 1852–56, it accommodated guests of the Palace and then was leased to the French School of Archaeology. It was purchased by Efstathios Lampsas, a former chef at the Palace, and Savas Kendros, owner of the nearby Megali Bretannia, and opened as the Grande Bretagne in 1874. It was reconstructed in 1958 to a design by E. Vogt that added four floors and enlarged the building. A major restoration by Athens architectural firm Pandelis Massouridis Associates, in collaboration with Hirsch Bedner Associates of Atlanta, USA, was carried out from November 2001 to March 2003. Among the many changes made, the grand lobby was returned to its full two-storey height and the Winter Garden, with its stained glass ceiling, restored. Athens's premier hotel boasts 321 suites and rooms.

Page 22
Athens Metro System
Construction of the main underground sections of the Athens Metro began only early in the 1990s, and the first section of Line 2 was opened in 2000. However, the earliest section of today's system, the surface 8-km stretch from Piraeus to Thiseion, was built from 1867–69 by Englishman Edward Pickering. It was extended underground through the city centre and electrified in 1904 and continued to Kifissia in 1957. The system's three lines now run for a total of 52 km and serve 45 stations. A second phase, begun in 2005, will add a further 26 km of track and 21 new stations of which 18 will be underground.

Page 22
St. Paul's Church (1838–43)
Vasilissis Amalias Avenue and Philellinon Street
The unlikely Victorian neo-Gothic Anglican church, constructed in granite imported from Scotland, was designed by English architect Henry Acland, revised by Charles Cockerell but again modified, before construction began, by the Danish Christian Hansen. It was built with funds largely raised by the local Anglican community.

Page 24
Schliemann's House (1878–81) (The Numismatic Museum)
12 Panepistimiou Street
One of the city's finest neoclassical buildings and one of architect Ernst Ziller's most important designs, this mansion was built for German archaeologist Heinrich Schliemann (1822–90) a wealthy, self-educated businessman who in his forties became a controversial pioneer of prehistoric archaeology. He excavated Troy (Ilion) in modern Turkey, Mycenae and Ithaca, and Schliemann named his house Iliou Melathron (Troy Mansion) in commemoration of his famous discovery. The splendid interior decoration includes mosaics and ceiling paintings based on Schliemann's finds.

Page 26
The National Library (1887–1902)
32 Panepistimiou Street at Ippokratous Street
The Vallianeios National Library is named after the three Russian Greek brothers who funded its construction. Statues in front of the building commemorate them. The design is by Danish architect Theophilus Hansen and the facade was remodelled by Ernst Ziller, who had supervised construction, in 1906.

Page 28
University of Athens (National Kapodistrian University) (1839–1864)
30 Panepistimiou Street
The University building designed by Hans Christian Hansen, elder brother of Theophilus, features an Ionic portico in Pentelic marble.

Page 29
Rallis House (c. 1840)
10 Korai Street, on the corner of Panepistimiou Street
This early mansion was originally owned by Dimitrios Soutzos (after whom it is frequently named) and rented from him by Andreas Syngrou from 1871 until 1873 while his own mansion, now the premises of the Ministry of Foreign Affairs (page 20), was being built. It later became the residence of Prime Minister Dimitrios Rallis (1844–1921), five times Prime Minister between 1897 and 1921. After years of commercial use, it was renovated in 1998.

Page 30
City of Athens Cultural Centre (1836–1838, extended 1858)
50 Akadimias Street
The original municipal hospital, one of the earliest public buildings of post-Independence Athens, was funded by King Ludwig of Bavaria and wealthy diaspora Greeks. It was later the University hospital and in 1972, after renovation by architect Kimon Laskaris, became the cultural centre of the municipality.

Page 31
The Arsakeion Extension (1900)
Stadiou Street
Ernst Ziller's airy building is an extension to, and harmonises well with, the much earlier Arsakeion, a neoclassical building designed by Lysandros Kaftantzoglou in 1846. This initially housed the first boarding school for girls in Greece, founded by Apostolos Arsakis (1792–1874), and is now occupied by the State Council.

The Rex Theatre (1937)
48 Panepistimiou Street
The influence of the Paris training of architects Vassileios Kassandras and Leonidas Bonis is apparent in this splendid Art Deco-style centre of entertainment. The theatre was owned by Marika

Kotopouli (1887–1954), a talented actress from a family of actors. In 1950 she instituted the Kotopouli Award for young actresses.

Page 32
National Historical Museum (the Old Parliament)
Kolokotroni Square
Constructed as the Parliament building from 1858–71, this neoclassical building, designed by French architect Francois Boulanger and later modified by Panagiotis Kalkos, replaced an earlier mansion which had been used for that purpose but was destroyed by fire in 1854. Having housed Parliament from 1875 to 1935, it was occupied by the Ministry of Justice and was converted to the National Historical Museum in 1962.

Page 33
The Museum of the City of Athens (1835, 1859)
Klafthmonos Square
The museum is housed in two connected buildings. That at 7 Paparrigopoulou Street was the residence of King Otto and Queen Amalia from 1836 until 1843. It was designed by Bavarian architects Luder and Hoffer for Stamatios Dekozis-Vouros, a wealthy merchant from Chios. The building was restored by architect Ioannis Travlos. The neighbouring building (no. 5), built for the son of Dekozis-Vouros, was designed by architect Gerasimos Metaxas in 1859. The facade was modified in 1916. Among the museum's displays, a 1:1,000 scale model of Athens in 1842, painstakingly constructed by Ioannis Travlos and artist Nikolaos Gerasimof, gives a striking insight into Athens as a city of 25,000 people.

Page 34
City Hall (Dimarkheion) (1872–1878; renovated 1901, 1935 and 1994–5)
Kotzia Square
The rather austere neoclassical-style City Hall was designed by Panagiotis Kalkos in 1872. He added a third storey between 1872 and 1878. A Doric porch dominates the facade, the ground floor of which is revetted in Pentelic marble. The rest of the building is cream stucco with marble accents.

Page 35
National Bank of Greece Buildings (1883–4; restored 1900, 1999–2001)
Kotzia Square
The Administration building was constructed in 1999–2001 to a design by Mario Botta. The former Vassileos Melas mansion was designed by Ernst Ziller in 1883–4 and, after being gutted by fire in 1900, was restored and became the Central Post Office of Athens.

Page 36
Omonia Square (1840)
Omonia (Concord) Square was planned to be the site of the palace, ultimately built on Syntagma Square, with gardens in front extending to what is now Kotzia Square. Built in 1840 as Otto Square, it was renamed in 1864 following the exile of the King.

Page 37
The National Theatre (1895–1901)
Agiou Konstantinou Street
The theatre was designed by the prolific Ernst Ziller. The facade, with its Corinthian columns, clearly owes a debt to Hadrian's Library and the interior was modelled on the Volkstheater in Vienna. An addition, designed by M. Perrakis, was built in 1970. Damaged by an earthquake in 1999, the theatre has now been restored and enlarged.

The ACROPOLIS and the OLD TOWN

Page 39
The Erechtheion (421–405 BC)
Acropolis
This masterpiece of classical Greek architecture replaced an earlier temple to Athena destroyed by the Persians. The six female figures on the Porch of the Caryatids are all copies. One of the originals is in the British Museum and the remainder have been removed for protection against acids in the atmosphere and are in the Acropolis Museum.

Page 40
The Parthenon (447–438 BC)
Acropolis
Built by the brilliant designer, Pheidias, who employed highly sophisticated optical "refinements" to offset distortions of perception by viewers of such a massive structure, it was originally adorned by sculptures and colour. The name Parthenon means "chamber of maidens" and referred to priestesses of Athena, whose 11.7 m-high ivory and gold-clad statue originally stood within. It was at least the fifth temple on this site.

The Odeion of Herod Atticus (AD 160–174)
Acropolis
The theatre was built in memory of Herod's Roman wife, Regilla. Herod Atticus (AD 101–177) hailed from a wealthy Marathon family. He was consul in Rome in AD 143, was later tutor to two Roman emperors, and when he retired to Athens, gave money for projects and monuments in Corinth, Olympia, Delphi and Athens, including the Panathenaic stadium (page 62).

The Theatre of Dionysos (sixth century BC)
Acropolis
The theatre, which underwent several major changes, is believed to have had a 17,000-strong seating capacity. Here, drama as we know it first evolved in the fifth century BC, out of rites to the god Dionysos Eleftherios. It was destroyed in the Herulian sack of AD 267 and was excavated from 1862.

Page 41
Hadrian's Gate (131 AD)
Vasilissis Amalias Avenue
Statues of Hadrian and Theseus once filled the central opening of the marble archway honouring Hadrian, one of Athens's greatest Roman benefactors. The emperor passed through it when he came to Athens for the inauguration of the Olympieion. When King Otto first entered the city in 1833, he followed his early predecessor and passed through the Arch of Hadrian which, in a take on the inscriptions on the gate, was adorned with a wreath bearing the words, "This is Athens, the city of Theseus and of Hadrian, now of Otto".

Olympieion (130 AD)
Vasilissis Amalias Avenue
The site on the west bank of the river Ilissos, where the remains of the Olympieion now stand, was first used for a temple by the tyrant Peisistratos in 515 BC. That work was abandoned and the materials used to build city walls. Work began on the present temple in 174 BC but was still not completed when it was badly damaged during the occupation of Athens by Sulla in 86 BC. Subsequently, many of the Corinthian-style columns were carried off to Rome. The temple was ordered rebuilt by Emperor Hadrian during his second stay in Athens (AD 124–25) and finally completed five years later.

Page 42
Monument of Lysikrates (334 BC)
Lysikrates Square
Built by Lysikrates of Kikyna to commemorate the success of his chorus in the drama contest of 334 BC, the monument is the best preserved of many which once lined Odos Tripodos, the Street of Tripods. The elaborate acanthus leaf finial on the top used to support a large bronze tripod, the prize awarded the winning chorus. In the 17th century, the area including the monument was sold to a French Capuchin order and adapted as the library of its convent. When the convent caught fire and had to be demolished, the monument survived, and was restored by the French in 1845 and 1892.

Pages 46 and 1
Tower of the Winds (Aerides) (c. 100 BC)
Roman Market
In origin, the tower was much more than a wind rose. It comprised a water clock and weather vane, had sundials on each wall and housed a device to track the movements of the planets. This combined meteorological station and planetarium is attributed to a Syrian astronomer Andronikos Kyrrhestes. Over its long history, it has been used as a Christian baptistery and a Muslim meeting house.

The Medresse (1721)
Pelopida Street
Originally the Turkish seminary founded by Mehmet Fahri, it comprised 11 student rooms around a colonnaded courtyard. Towards the end of Turkish rule the Medresse was converted into a prison of some notoriety. Refurbished, it continued to be used as a prison after Independence until 1911. In 1919, a large plane tree in the courtyard, which had been used as a gallows during Turkish rule, was struck by lightning, and that year most of the building was demolished.

Page 47
The Fethiye Tzami (Mosque of Victory) (c. 1458)
Panos Street
The mosque was named in commemoration of the fall of Constantinople. For five months in 1687–88 Venetian occupiers converted it into the Catholic Church of St. Denis, after which it resumed its original role until the War of Independence.

The Roman Market (51 BC–19 BC) and Gate (c. 10 BC)
Pelopida Street
The market, completed by Octavian Augustus after whom it was named, was destroyed during the sack of Athens by the Herulians in AD 267. During the Byzantine and Ottoman periods, the area was covered with workshops and houses. A large part of it was excavated spasmodically from the 1930s to 1960s.

Page 49
Hadrian's Library (AD 131), the Tetraconch Church (AD 412), and the Church of the Great Virgin Mary (11th century)
Areos Street
What was later to be characterised as a library was founded by Emperor Hadrian in AD 132. It consisted of a wall enclosing a rectangular colonnaded courtyard with 100 marble columns. The entrance portico was on what is now Areos Street. The library was heavily damaged during the Herulian invasion of AD 267, was incorporated into the defensive wall constructed immediately after, and for the next 800 years was principally a civic and commercial centre. In Ottoman times the interior was the principle bazaar of the city and the seat of the Turkish Governor. Under King Otto it housed a barracks. The monumental Tetraconch Church, named after four semi-circular recesses which were a feature of its design, was built within the inner courtyard of Hadrian's Library about AD 410 but ruined about 300 years later. In the 11th century, the Church of the Great Virgin Mary was built on the site. It was destroyed by fire in 1884.

Page 51
Athens Cathedral (1842–62)
Mitropoleos Square
The cathedral was the work of a succession of architects. Theophilus Hansen did the initial design. A modification giving it a more Greco-Byzantine aspect by Dimitrios Zezos was not completed before he died. Panagiotis Kalkos and Francois Boulanger completed the work. The result of so many influences is an ill-defined architectural character and a top-heavy building. It is dedicated to the Annunciation of the Virgin.

Page 53
Kapnikarea (c. 1060)
Ermou Street
Kapnikarea is dedicated to St. Mary. Originally cruciform in plan, it was extended during the 12th and 13th centuries. Four columns used to support the central dome are of Roman origin. The interior finish is mostly modern and includes frescoes by Photis Kontoglou (1955); the mosaic over the entrance is by Elli Voïla (1936). The origin of the name Kapnikarea is obscure. It may be related to a Byzantine era tax, the "kapnikon", or to a sponsor with the family name of Kapnikares.

Page 54
The Temple of Hephaestus (Theseion) (449–415 BC)
Ancient Agora
The Doric-style marble temple was built on a prime site probably by the architect who also designed the Temple of Poseidon at Sounion. It was long believed to be dedicated to the legendary King Theseus, the founder of Athens, and thus took the name Theseion by which it is still commonly known. However, it has been established that it was dedicated to the gods Hephaestus and Athena. Hephaestus was the god of fire who also, at the behest of Zeus, helped to create the first woman.

Page 56
The Old Observatory (1843–46) and St. Marina's Church (started 1922)
Hill of the Nymphs
The neoclassical observatory was designed by Danish architect Theophilus Hansen—who also was responsible for the National Library and the Academy (pages 26 and 27)—and built with funds provided by Baron Simon Sinas, whose other philanthropy included the Academy. The main Athens observatory is now at Pendeli. The modern Byzantine-style church was based on the design of architect Achilleas Georgiadis. Notable interior decorations are murals of religious scenes, most done in the 1930s by A. Graikos and A. Kandris, and a wooden screen is by Georgios Nomikos.

LYCABETTUS and the NEIGHBOURHOODS

Page 60
Zappeion Hall (1874–88. Renovated 1959–60)
When he agreed to finance an agricultural, industrial and art exhibition, Evangelos Zappas hired French architect Francois Boulanger to draw up plans. Building was delayed by Zappas's death but was continued by his brother Constantinos to

plans modified by the Danish architect Theophilus Hansen, to whom credit for the neoclassical masterpiece is due.

Page 61
The Presidential Mansion (1891–97. Additions 1910, 1964)
Irodou Attikou and Vasileos Georgiou II Streets
Ernst Ziller was commissioned to design this mansion in 1888. A ballroom, added at the north end in 1910, was designed by architect Anastasios Metaxas.

Page 62
The Panathenaic Stadium (restored 1869–70)
Vasileos Konstantinou Avenue
An early stadium, rebuilt with marble seating by Herod Atticus for the Panathenaic games of AD 144, was abandoned during the Middle Ages and stripped of its stone. In 1869–70, Ernst Ziller restored the stadium and finished it in marble for the first modern Olympics in 1896 with funds contributed by one of Greece's most notable public benefactors, Georgios Averoff. The architect Anastasios Metaxas supervised the works, and the inauguration of the stadium was celebrated on March 25, 1896, Greece's national day.

Page 63
Melina Mercouri (1922–94)
Charismatic and much loved, Mercouri was born in Athens where she became well known as a stage actress. She gained international recognition—and put modern Greece on the post-war map—with her film, "Never on Sunday" (1960), directed by Jules Dassin whom she later married. She was deprived of her citizenship for criticising the military dictatorship (1967–74) and campaigned abroad against it. On her return, she became a politician and was made Minister of Culture in 1981. Mercouri died in New York in 1994.

Page 64
The Truman Statue (1963)
Truman Square, facing Vasileos Konstantinou Avenue
The 3.7 m-high bronze, a gift from the American Hellenic Educational Progressive Association (AHEPA), is the work of Felix W. de Weldon. He earlier created the stunning "Iwo Jima" memorial to the US Marine Corps in Washington, DC, depicting Marines raising the Stars and Stripes on Mount Suribachi.

Page 65
Megaron Stathatos (1895)
31 Vasilissis Sofias Avenue
This fine mansion was built by Ernst Ziller for Othon and Athina Stathatos. It was occupied by the family until 1938. The N. P. Goulandris Foundation was granted a lease on the building in 1991 to accommodate a much needed expansion of the Museum of Cycladic Art. Modifications were carried out by Pavlos M. Calligas and the buildings connected by a glassed-in corridor designed by Ioannis Vikelas.

Benaki Museum (house built 1867–68, remodelled 1911, 1931, 1973, 1989–97)
1 Koumbari Street
The neoclassical house was built for merchant Ioannis Peroglou. After it was bought by Emmanouil Benakis, it was remodelled and extended by architect Anastasios Metaxas who also designed all the alterations for the 1931 opening of the museum. The Benaki Museum also incorporates five other centres widely scattered in greater Athens including the excellent Museum of Islamic Art, housed in two finely-restored marble-faced neoclassical houses on Dipylou Street in Kerameikos.

Page 66
Byzantine and Christian Museum—Villa Ilissia (1840–48)
22 Vasilissis Sofias Avenue
The Villa Ilissia was designed for the Duchesse de Plaisance (1785–1854) by the Greek architect Stamatios Kleanthis and is the only remaining building in Athens designed by him. The Italian Renaissance-style marble villa was named after the ancient name of the district in which it stood. The museum, established in 1914, was installed in the villa in 1930 after it had been restored by art collector and architect Georgios Sotiriou with architect Aristotle Zachos. It has since been extended by Manos Perrakis.

The National Gallery of Art (1964–74)
50 Vasileos Konstantinou Avenue
The gallery's collection, founded in 1900, was joined with that of Alexandros Soutzos in 1954 and has been swelled by many donations and bequests. The starkly-modern building, designed by architects Fatouros, Milonas and Moutsopoulos, is to be expanded.

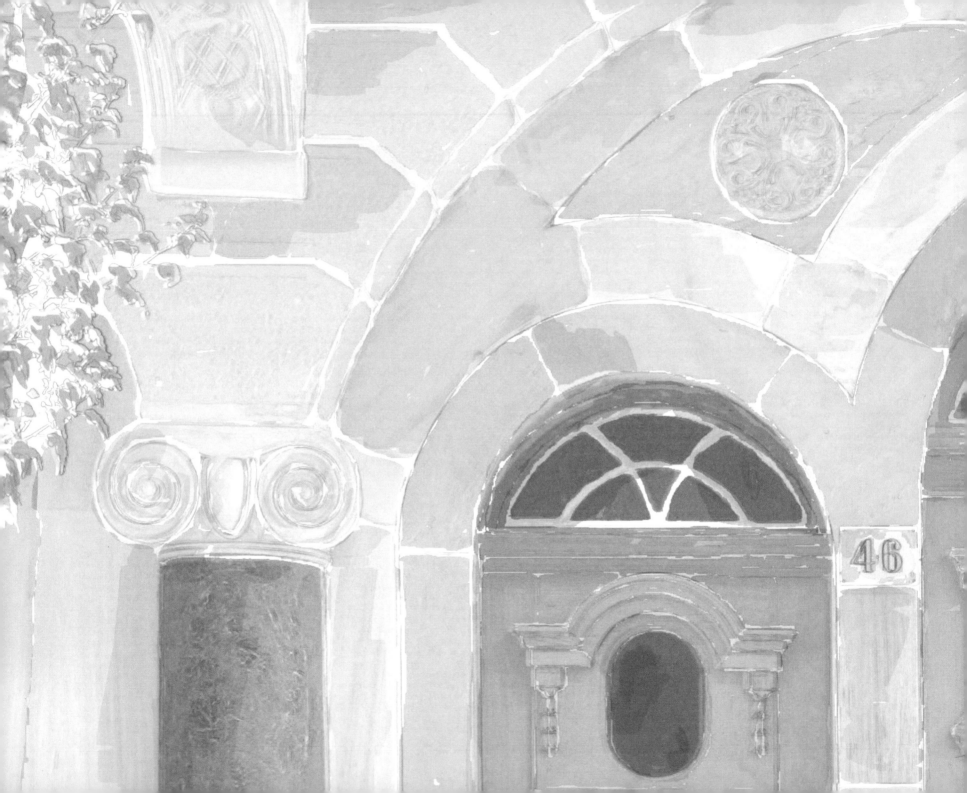